Crazy Emoji & Emotion Monsters Awesome Coloring Book

By

Adriana P. Jenova

Anti-Stress Art Therapy adult coloring book

Volume 3

Published by PUBLISHING COMPANY in 2016
First edition: First printing
Illustrations and design © 2016 Adriana P. Jenova

allcoloringbook.com

All rights reserved. No part of this book may be reproduced or transmitted in any form or by any means, including but not limited to information storage and retrieval systems, electronic, mechanical, photocopy, recording, etc. without written permission from the copyright holder.
ISBN-13: 978-1540673121
ISBN-10: 154067312X

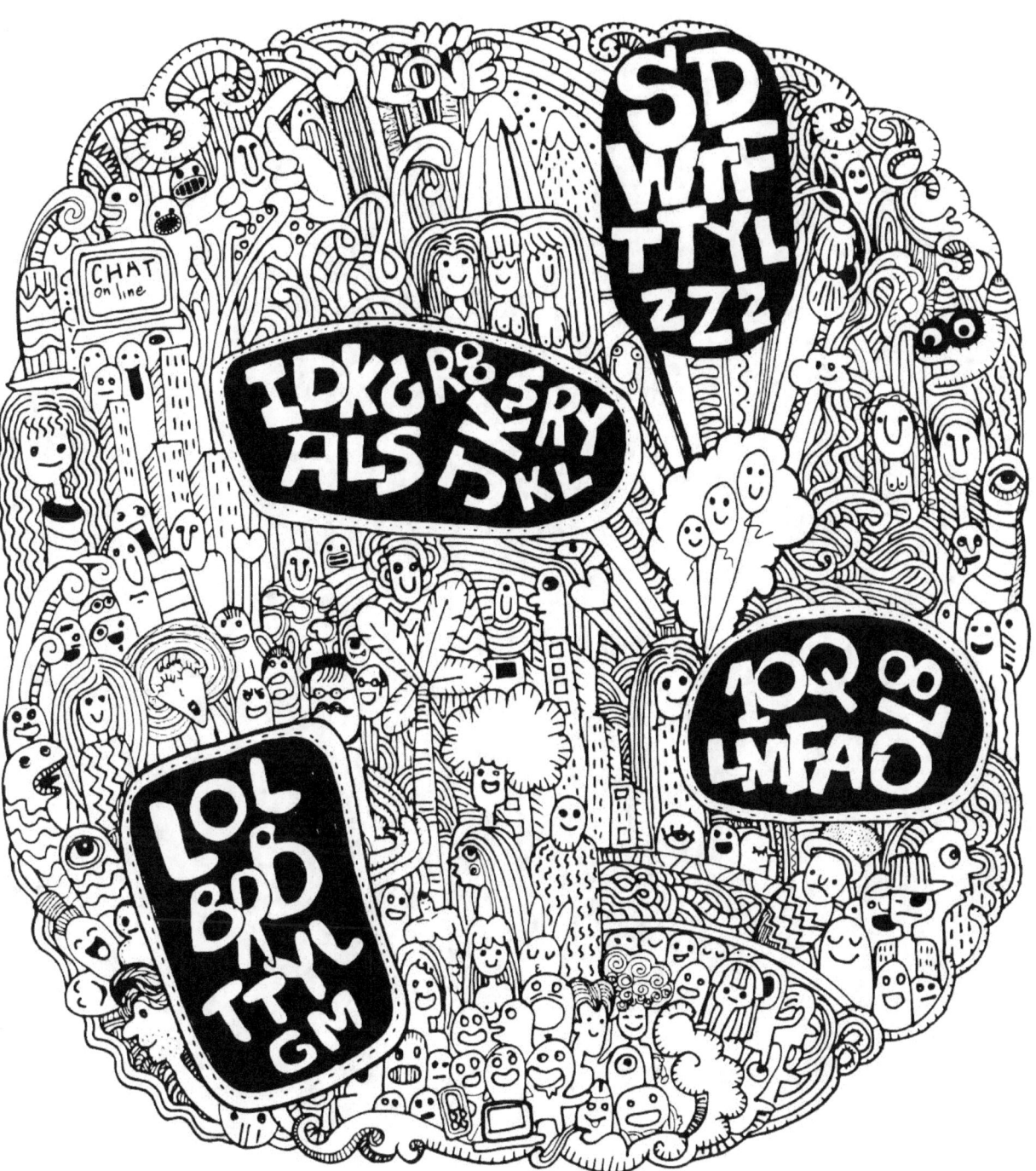

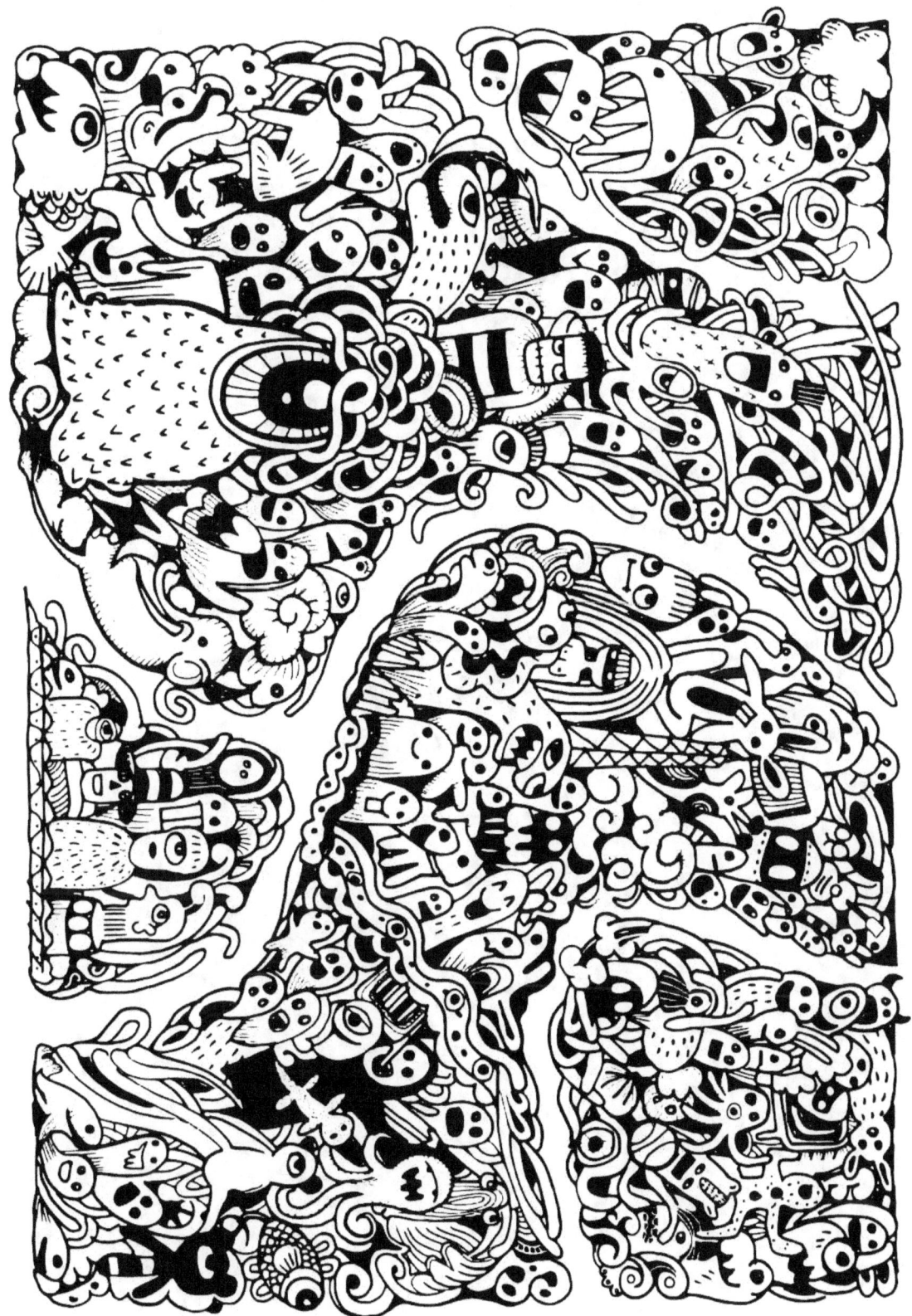

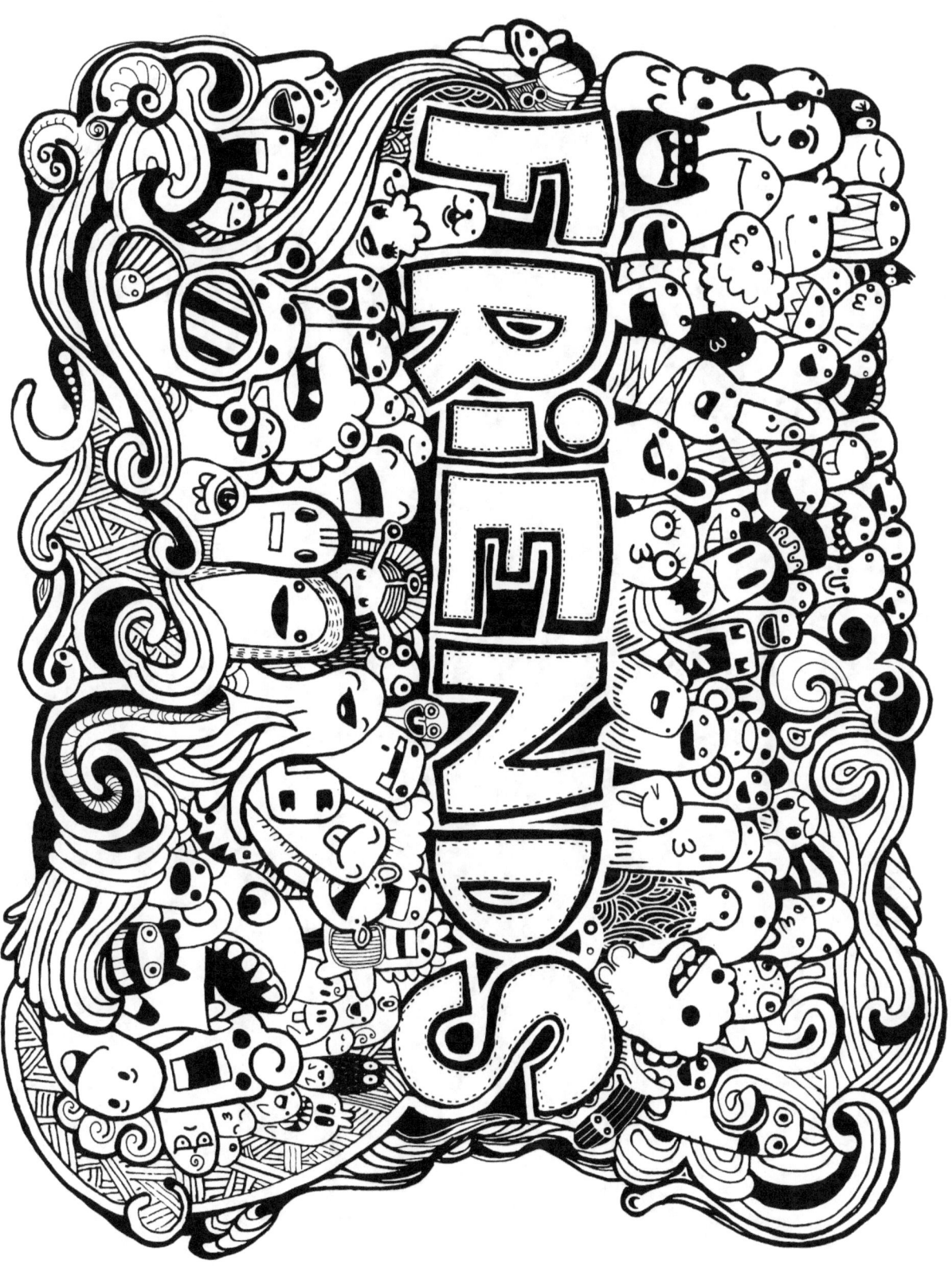

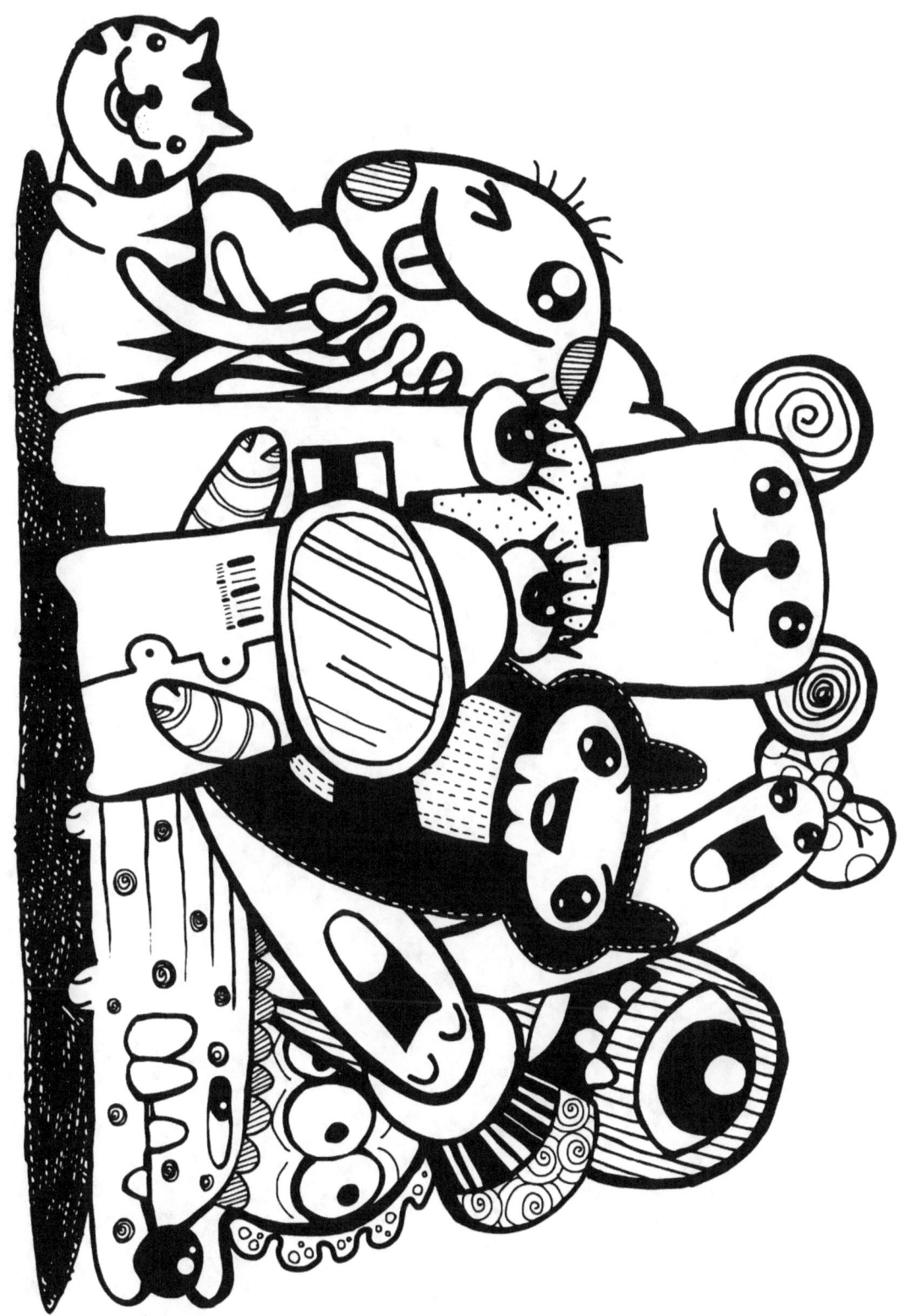

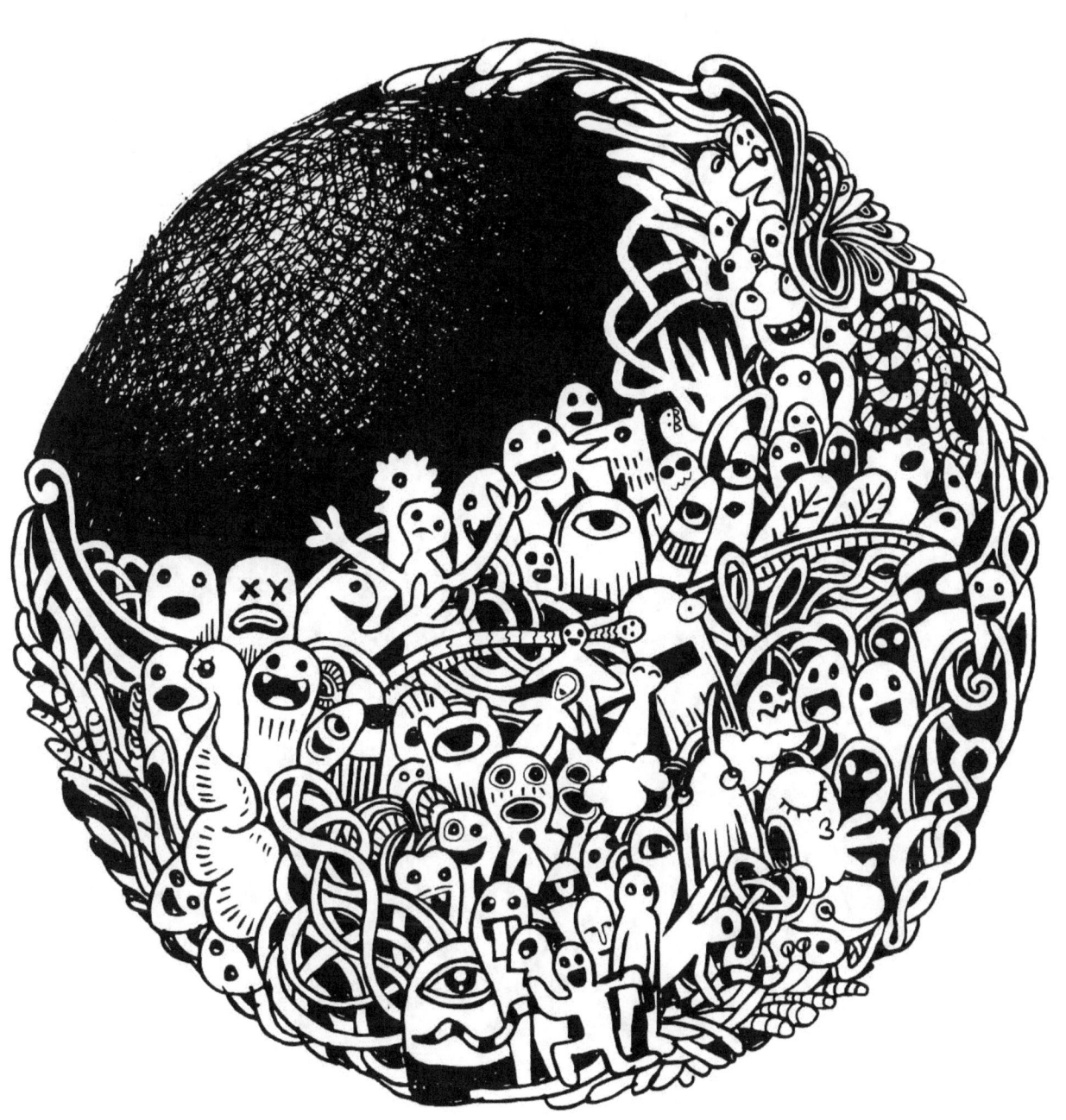

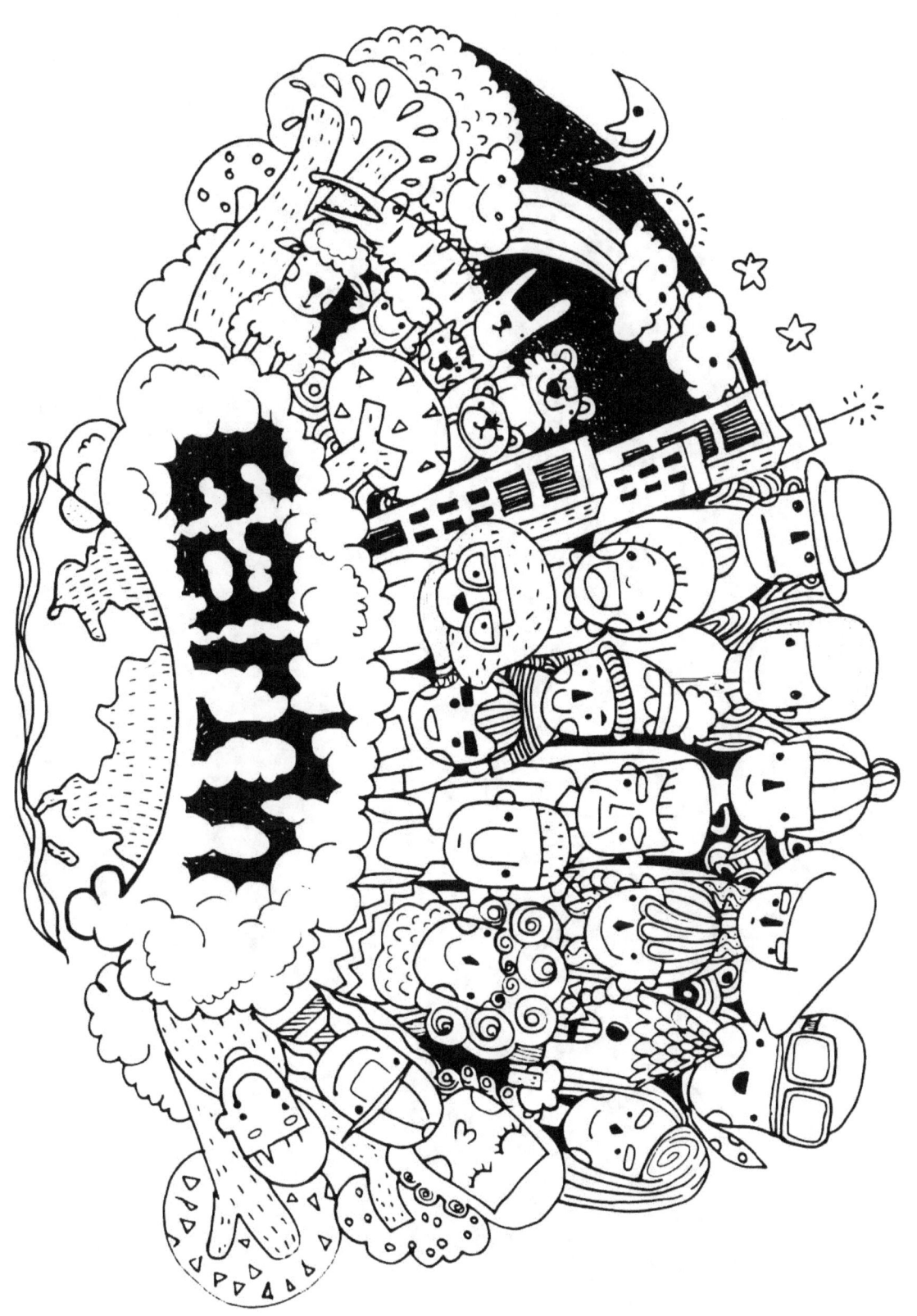

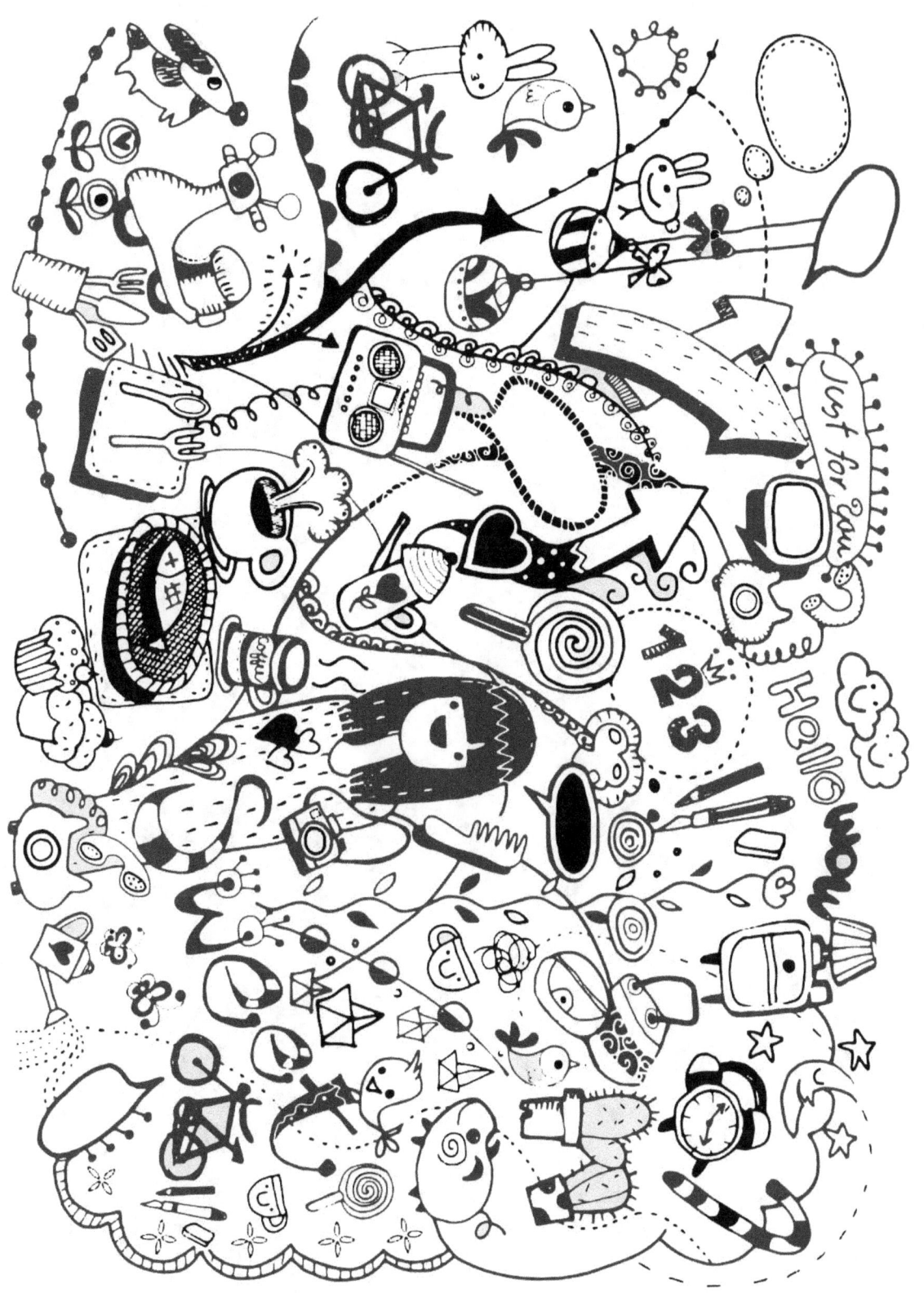

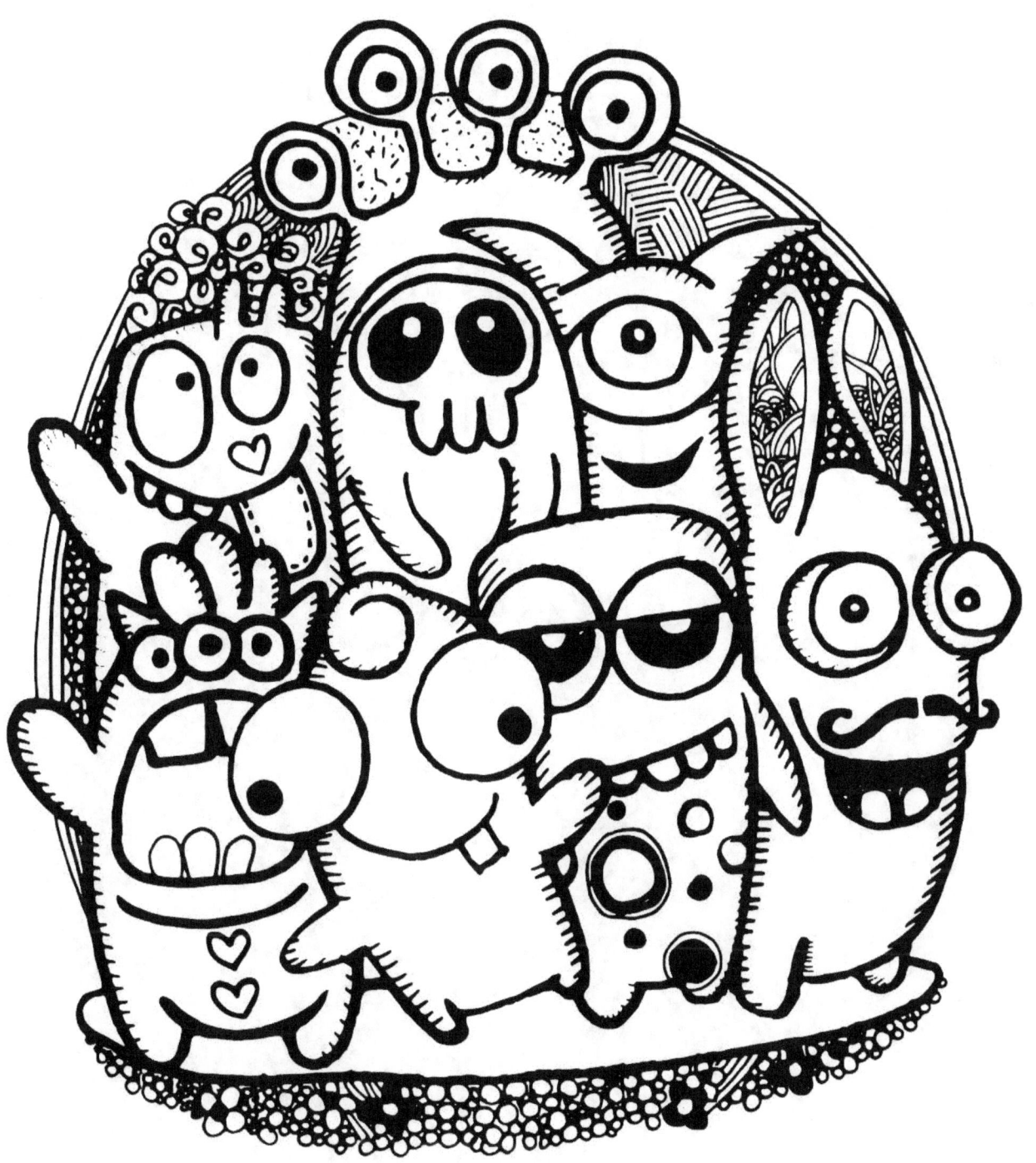

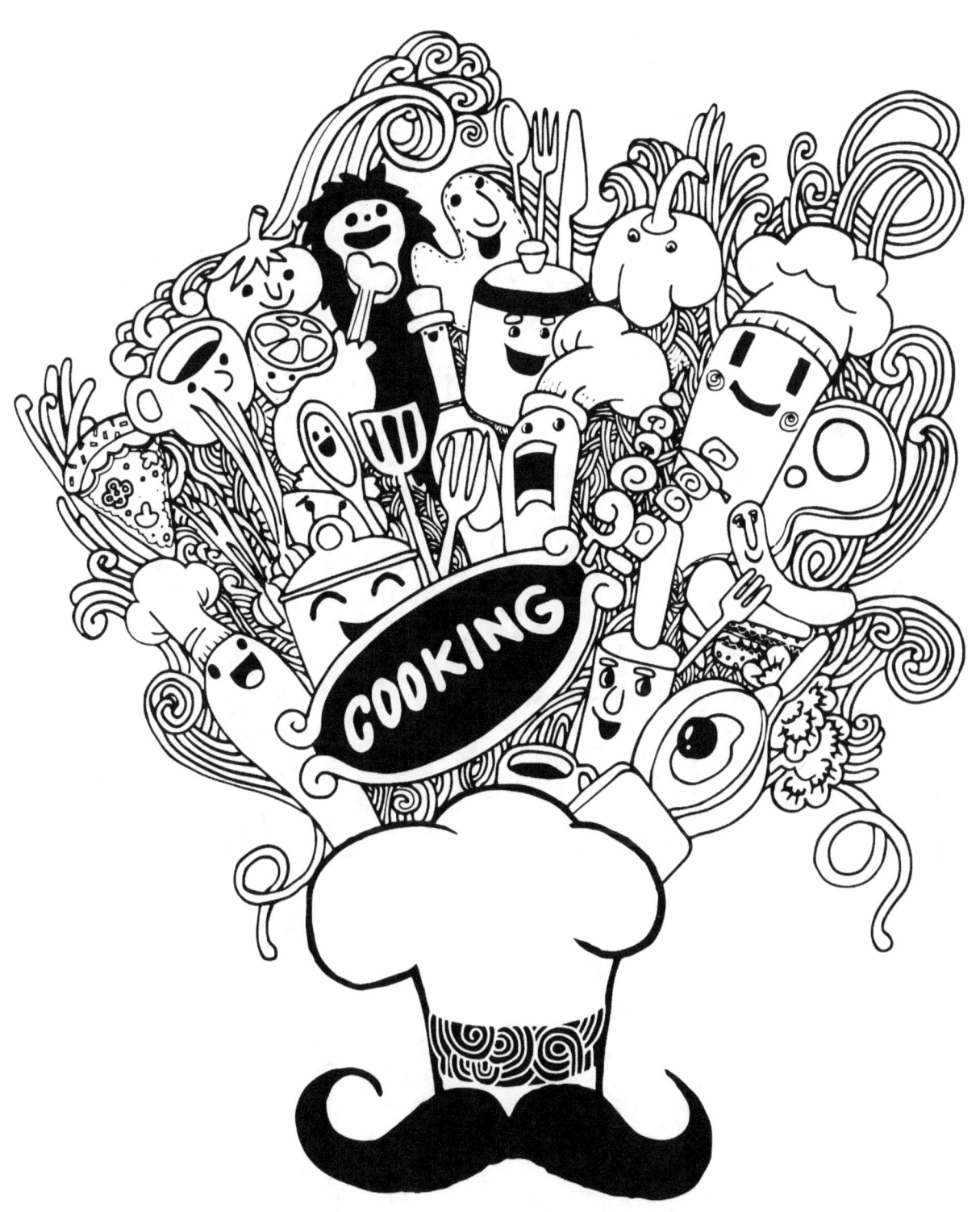

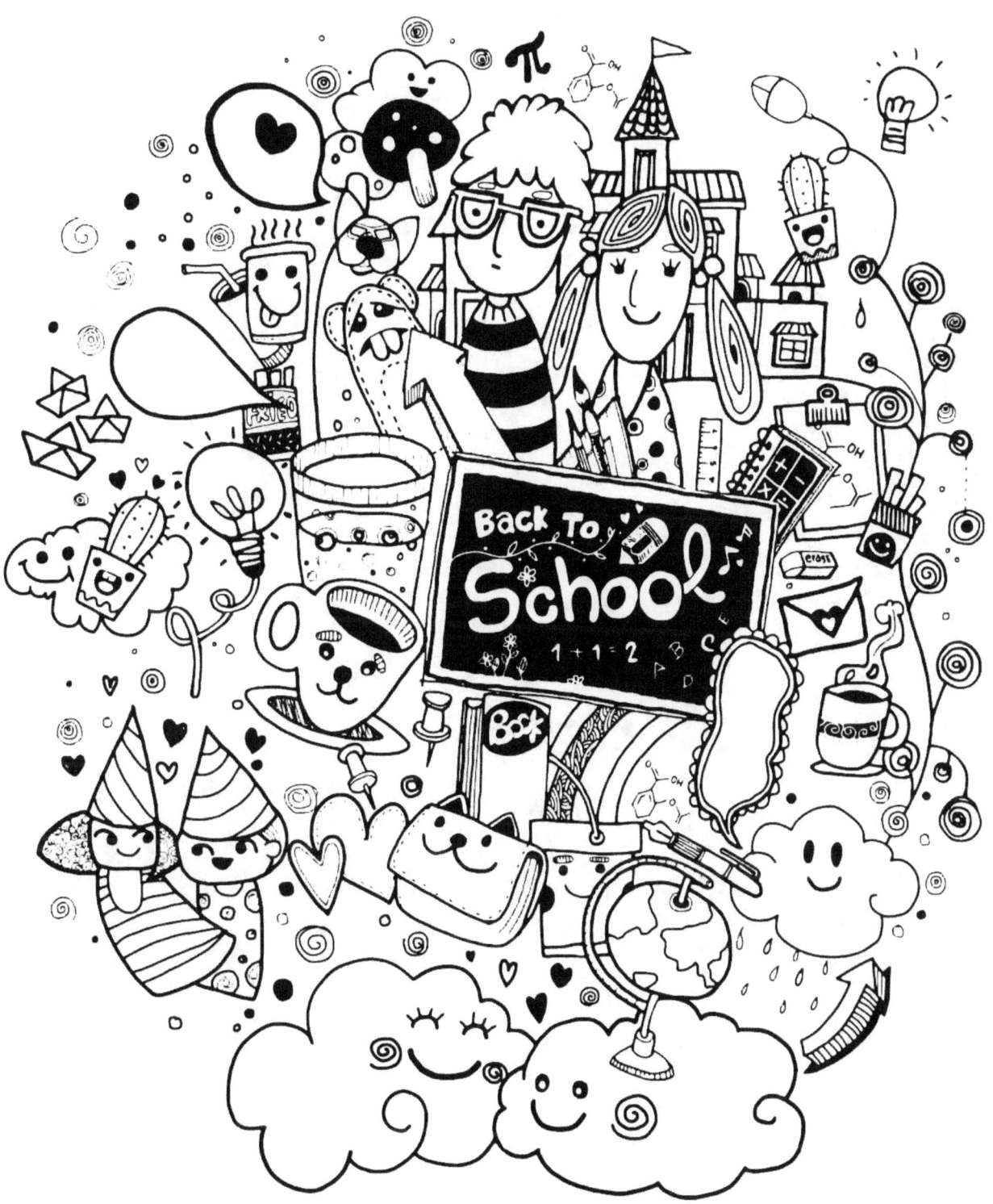

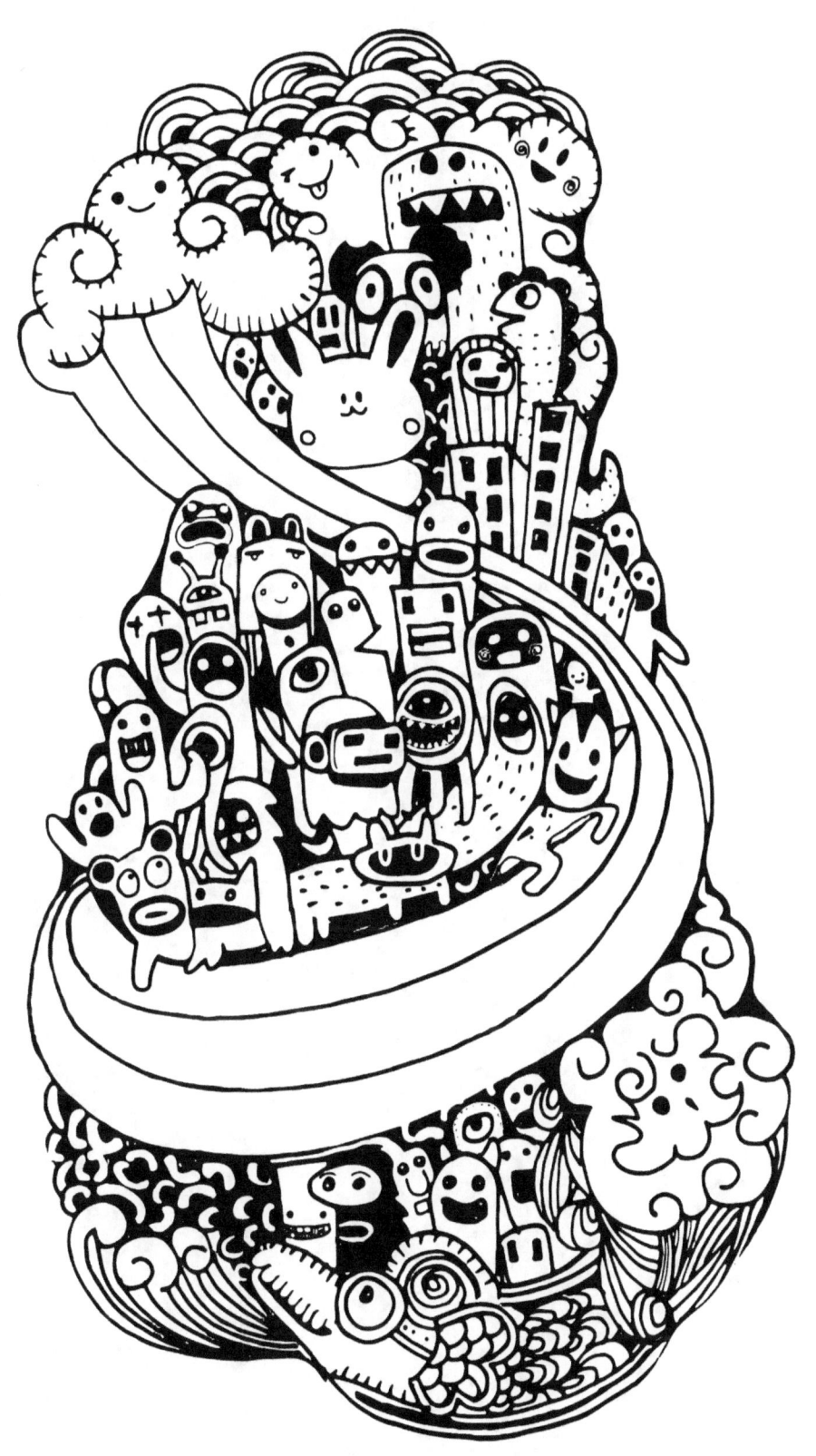

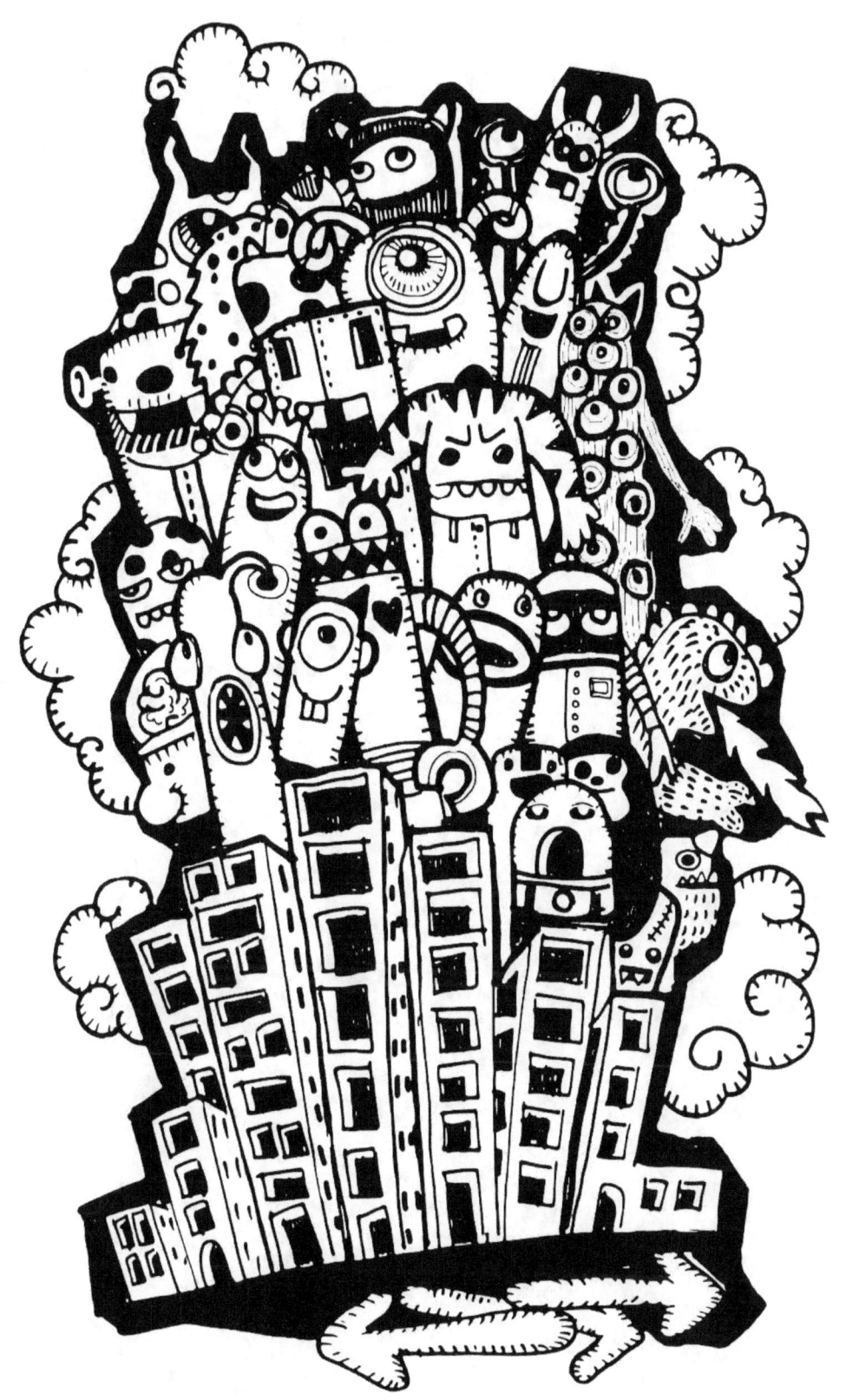

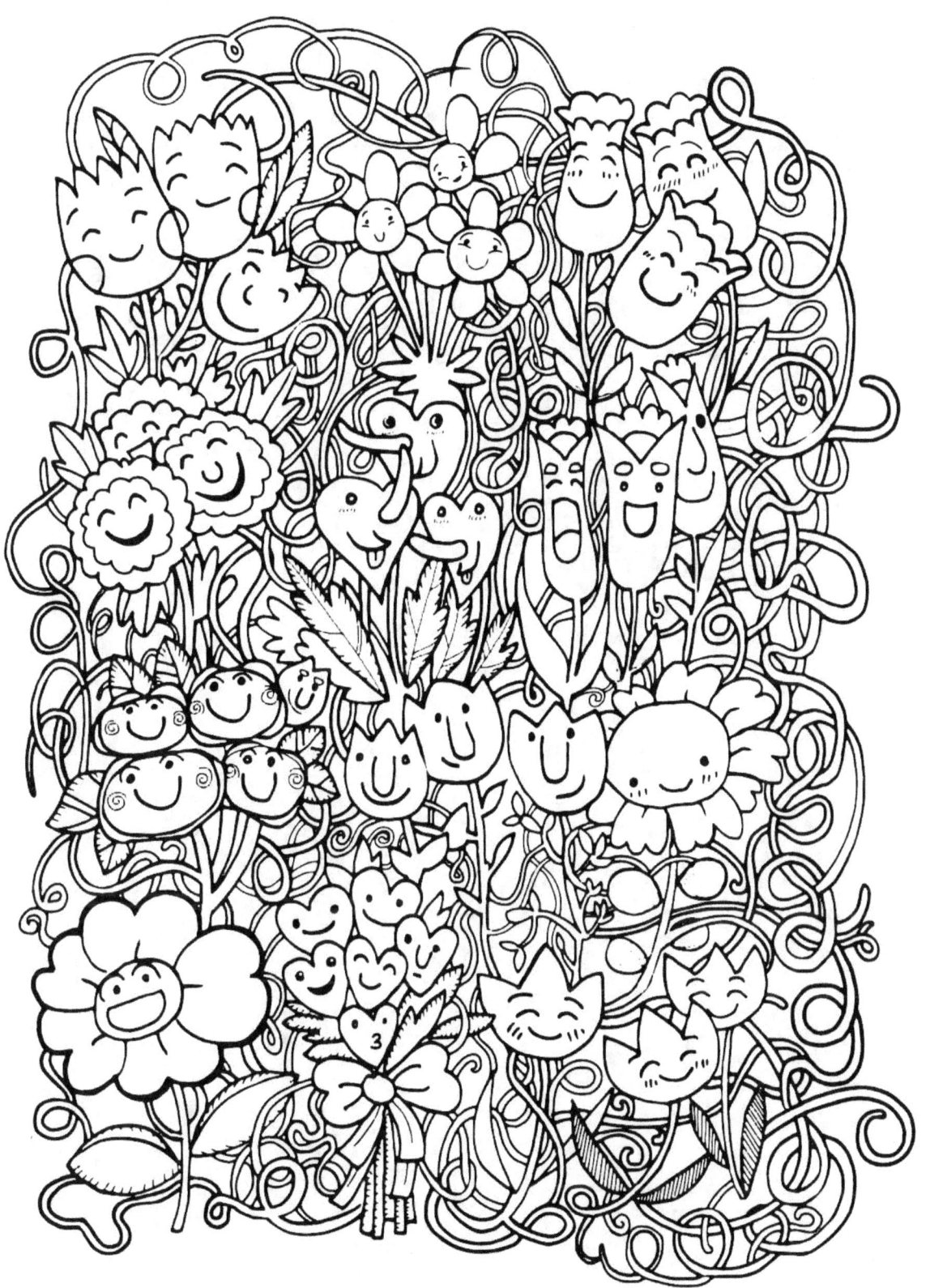

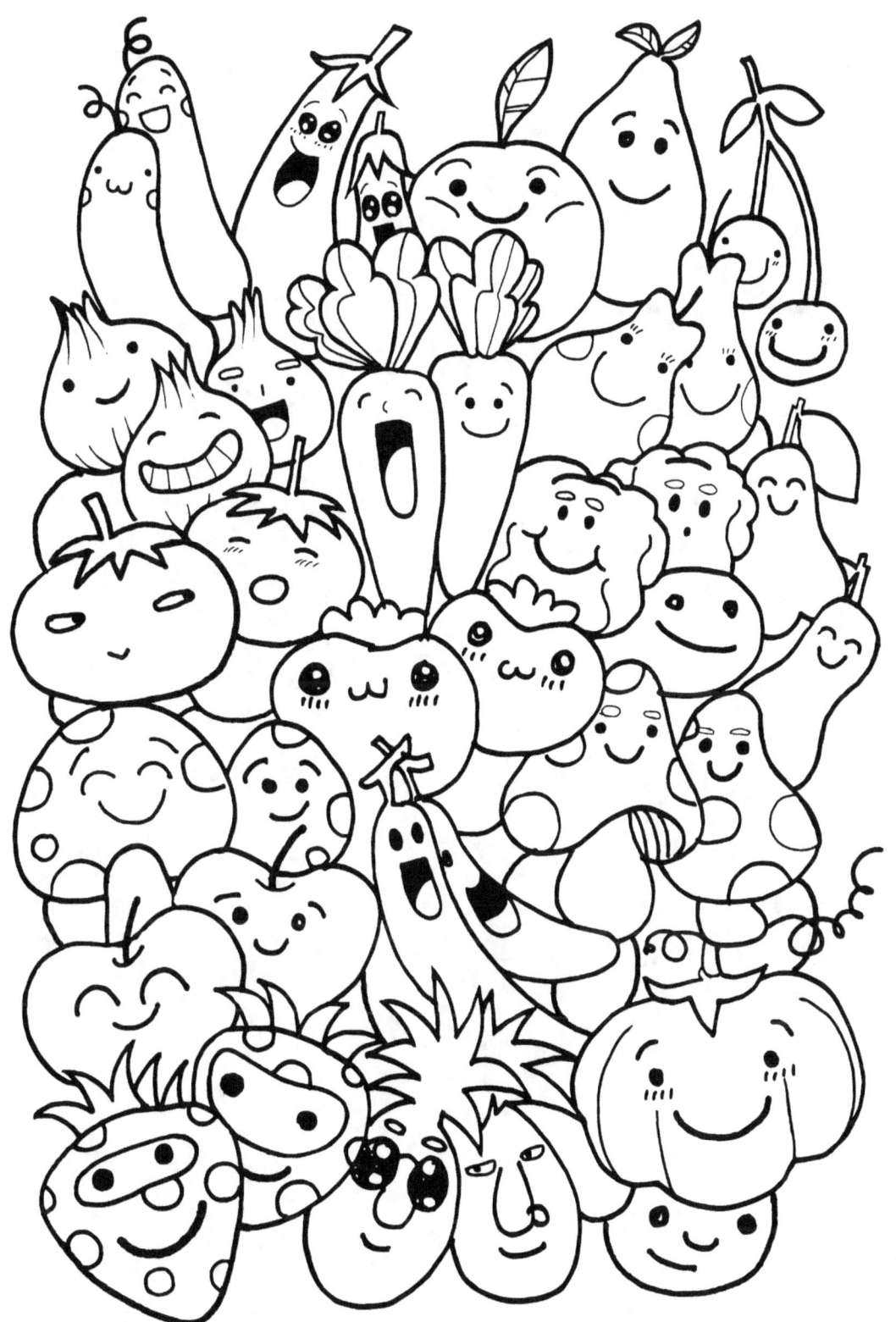

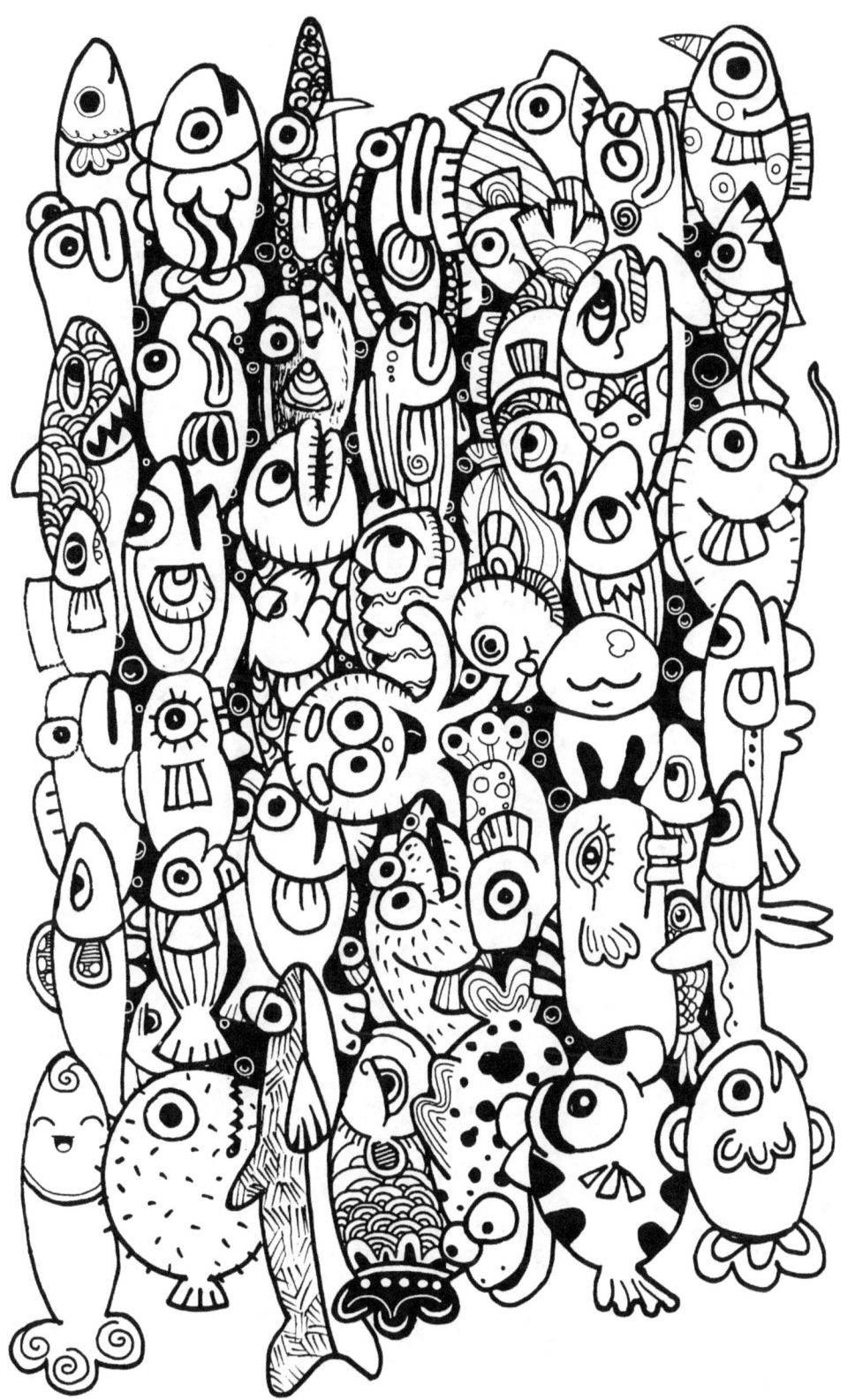

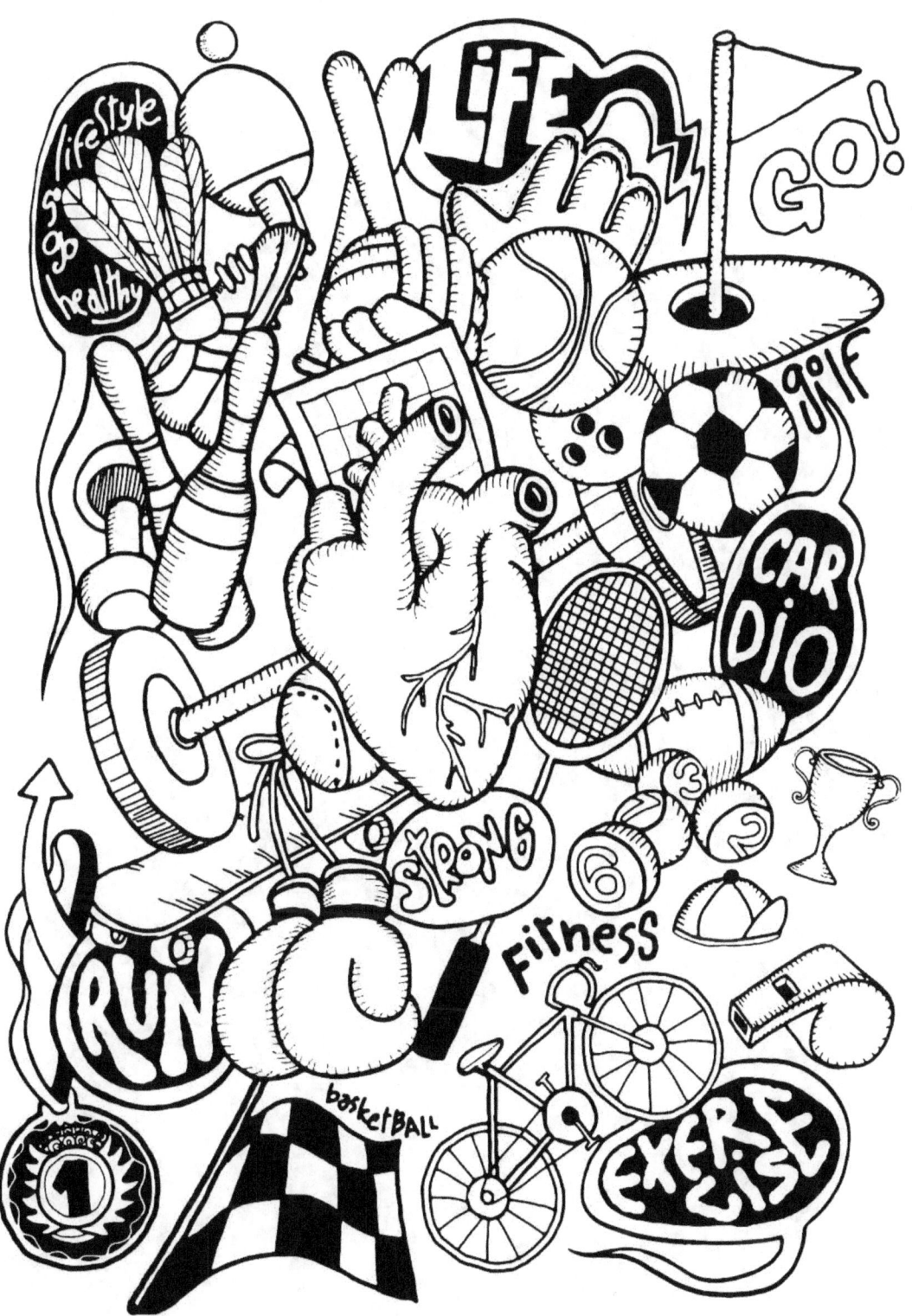

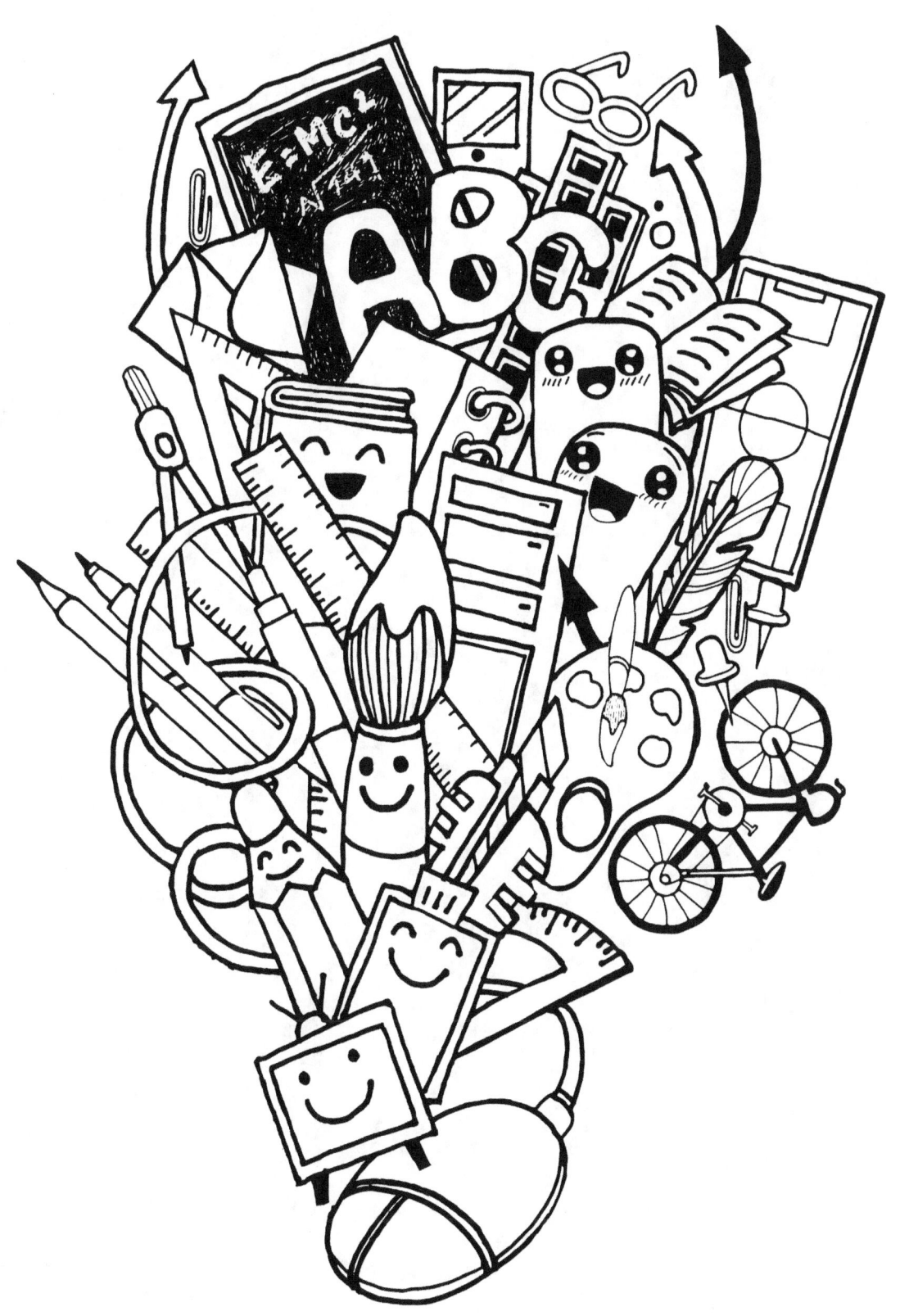

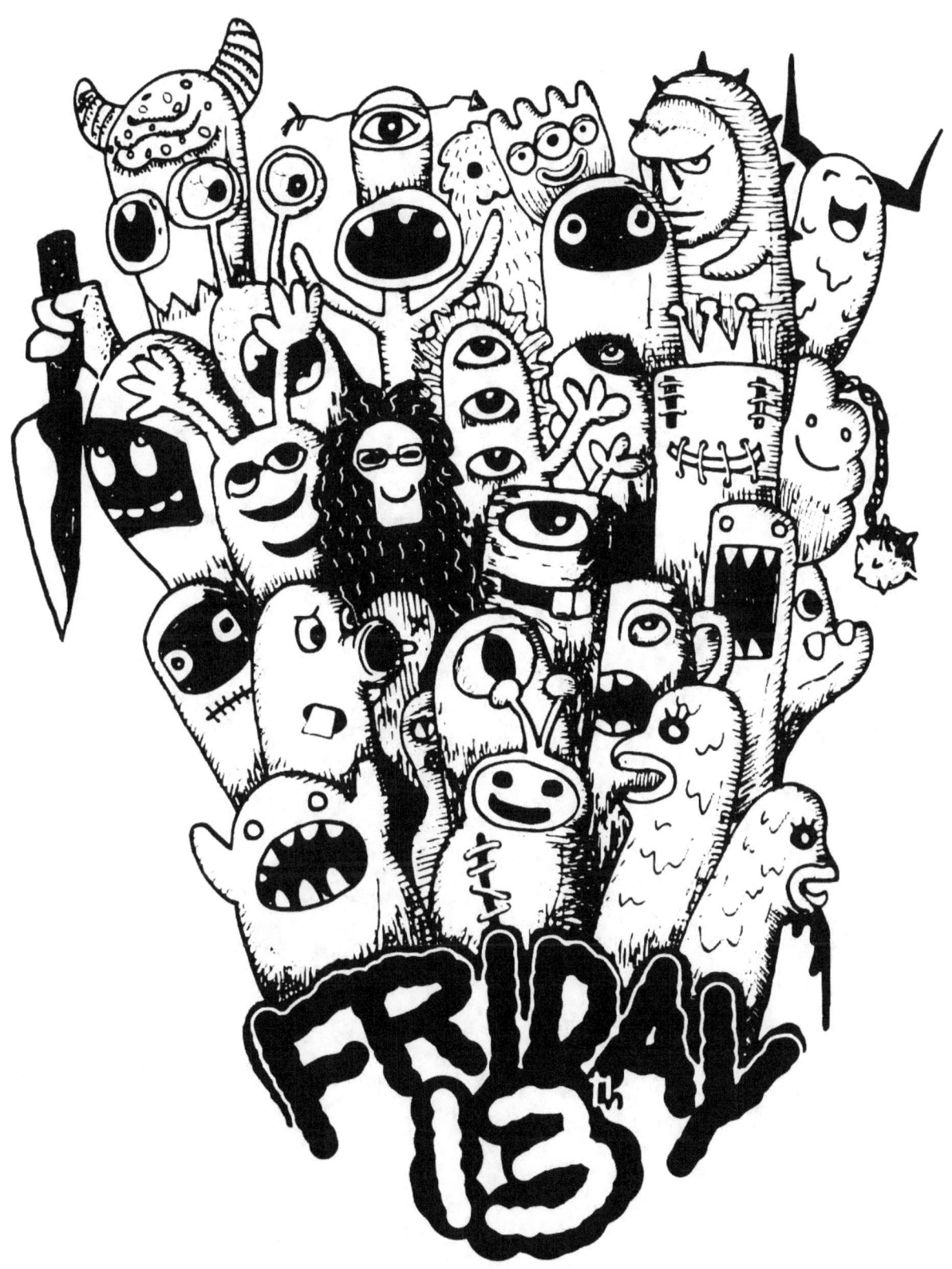

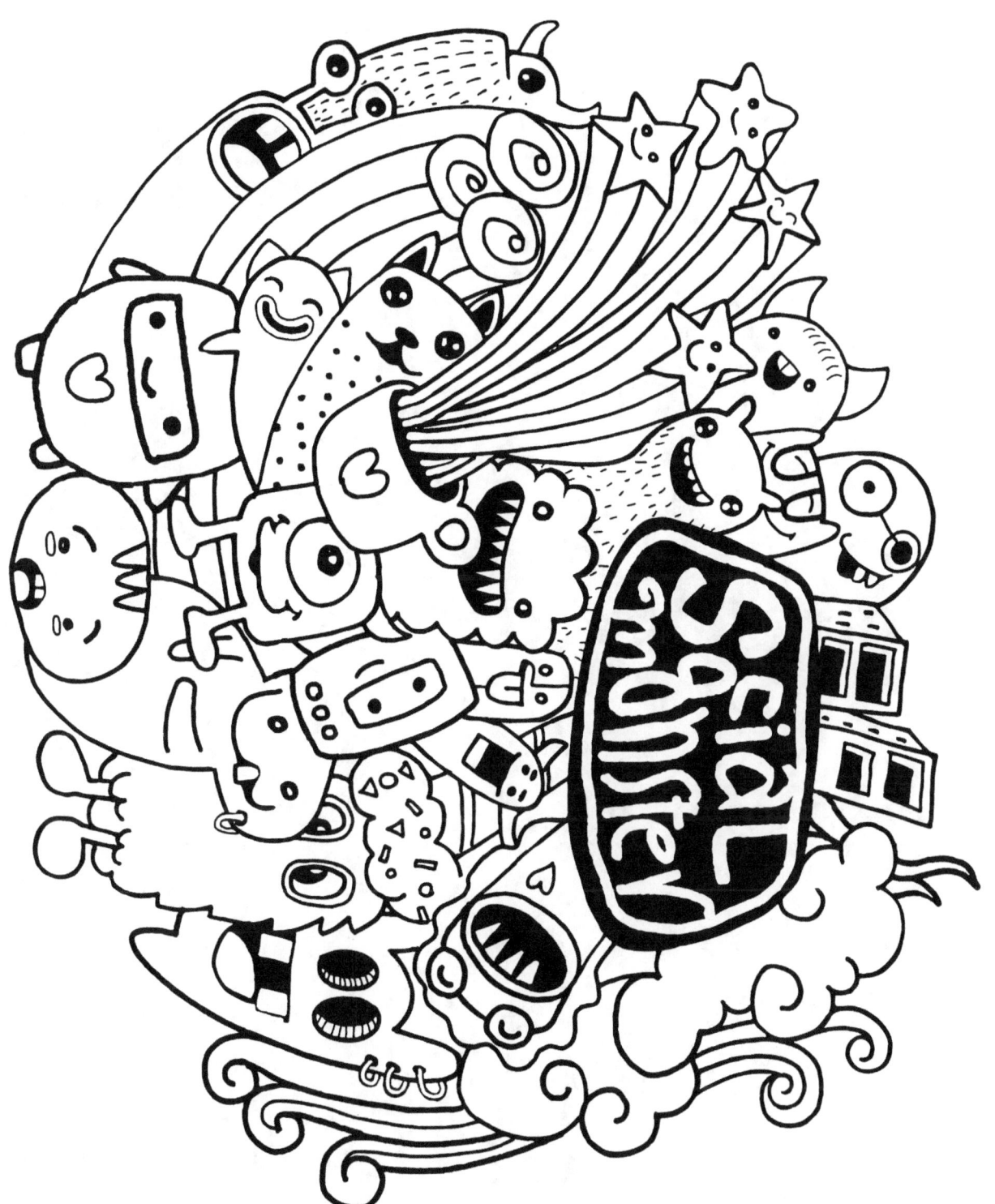

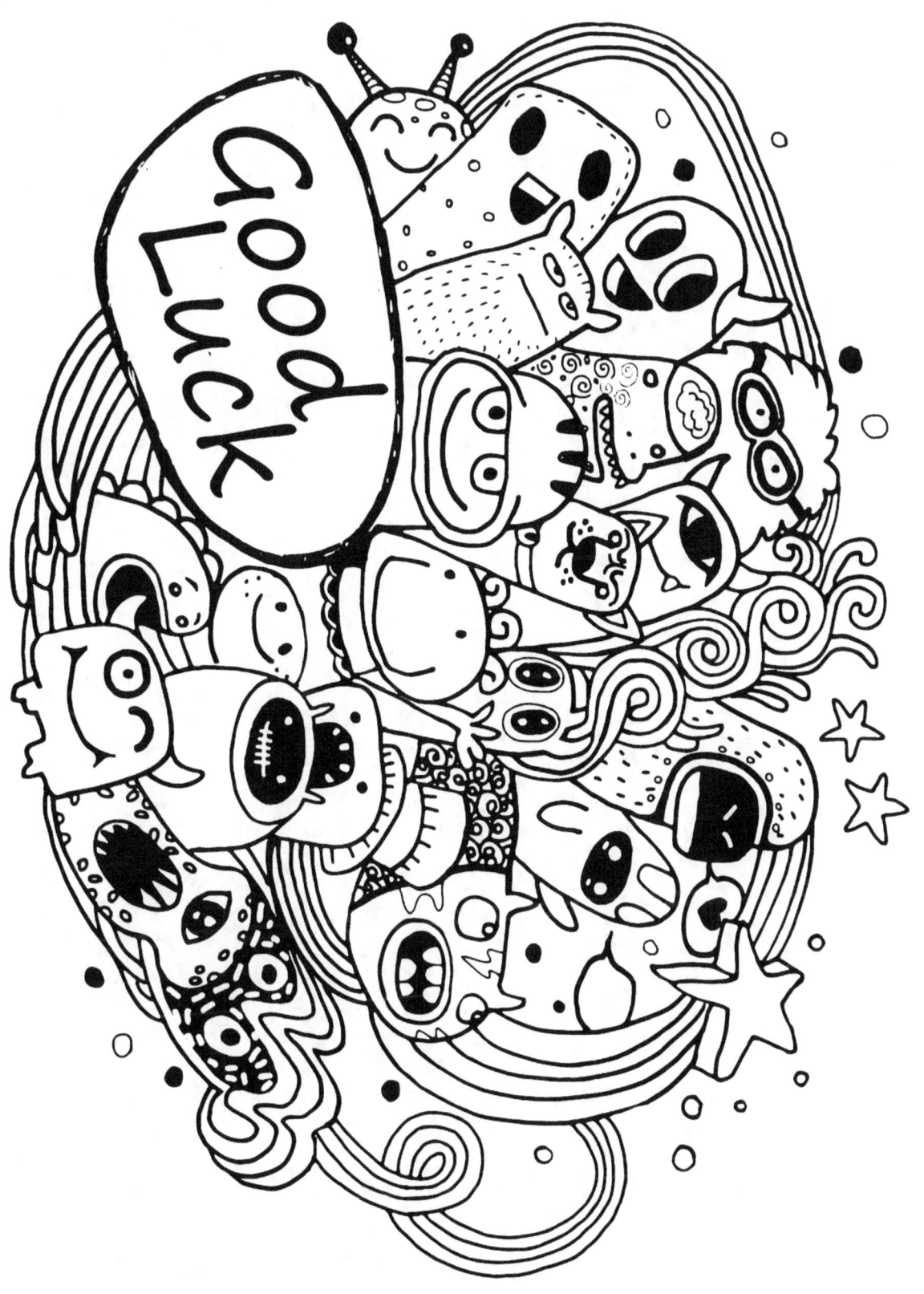

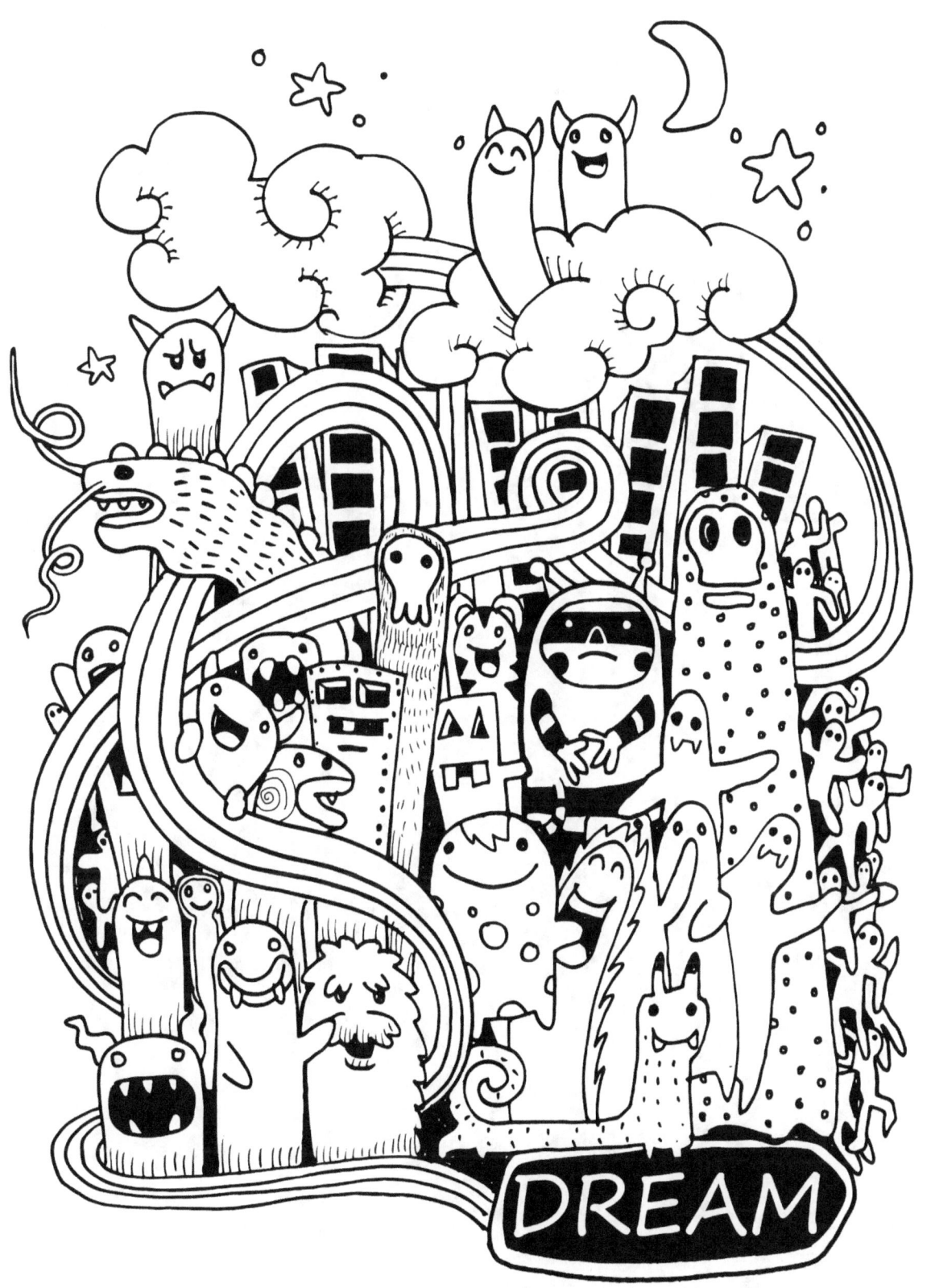

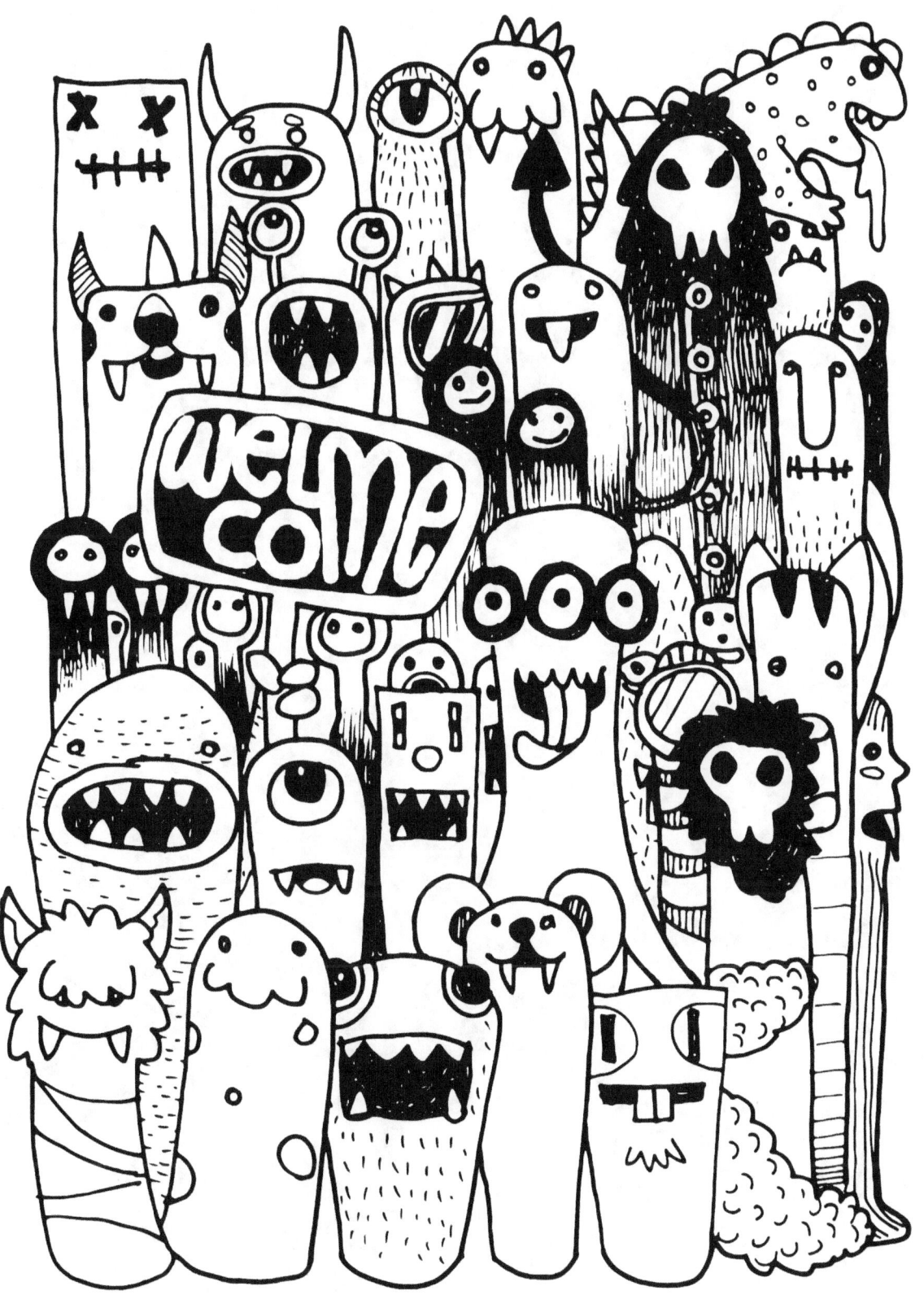

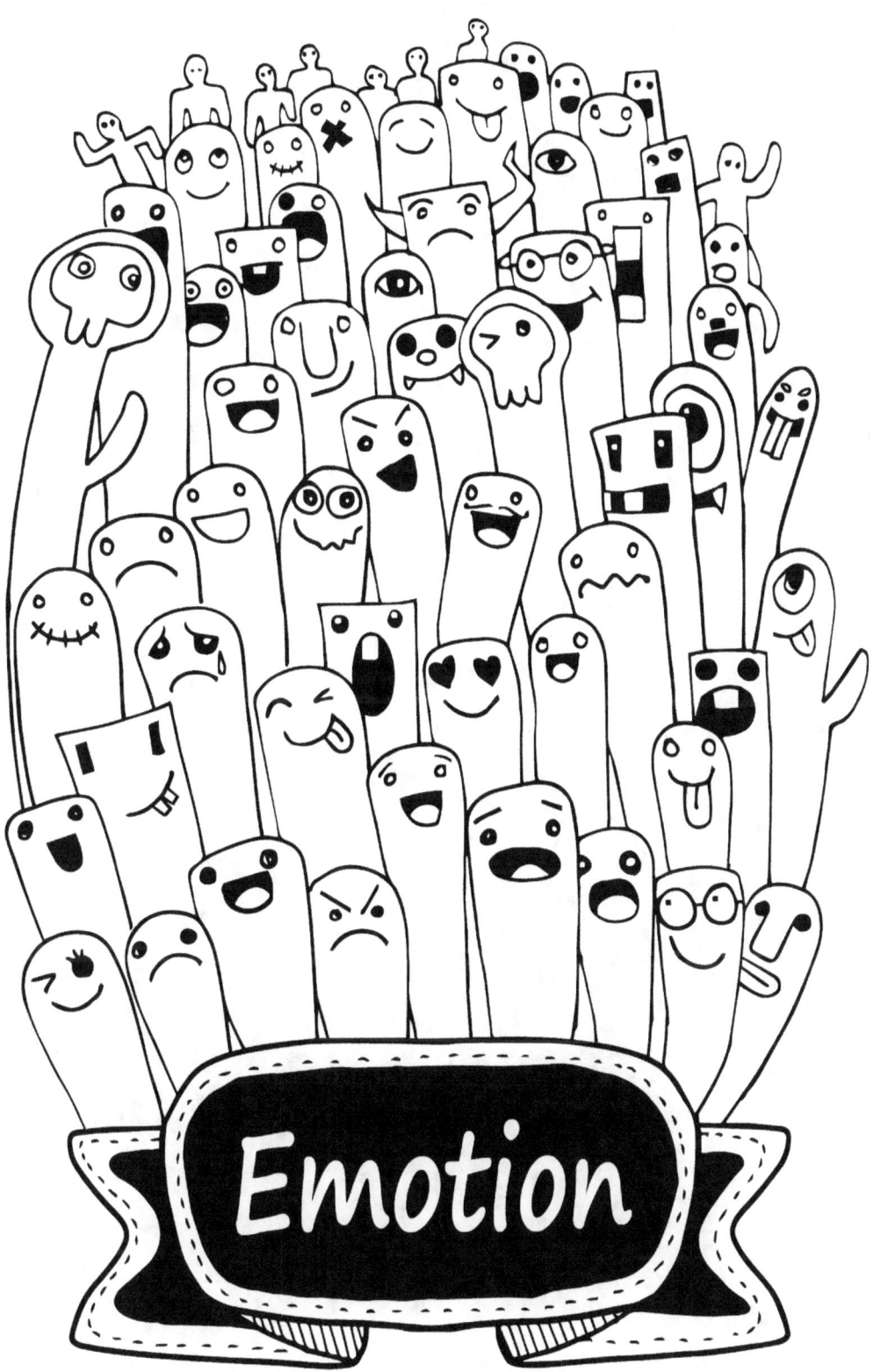

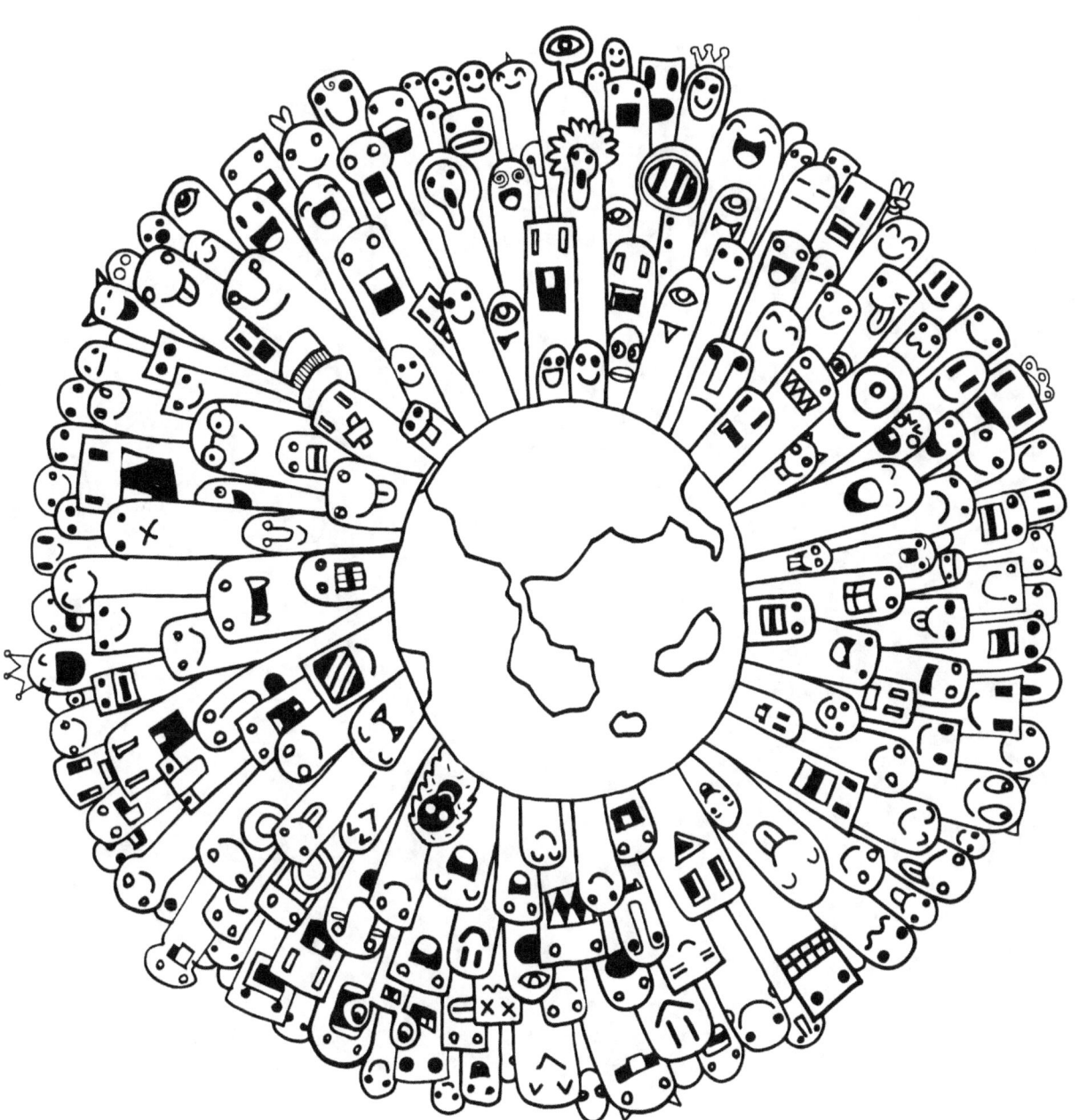

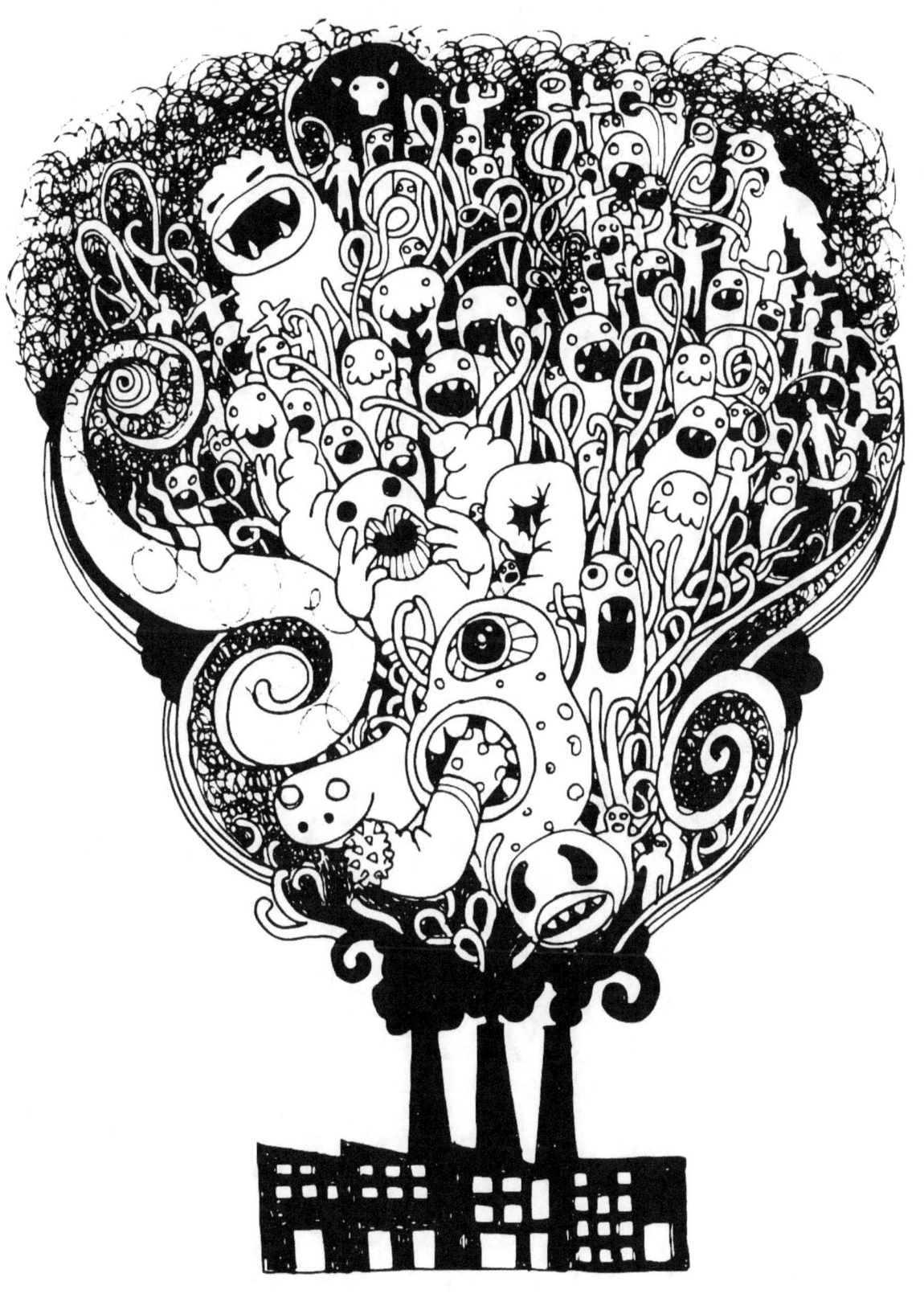

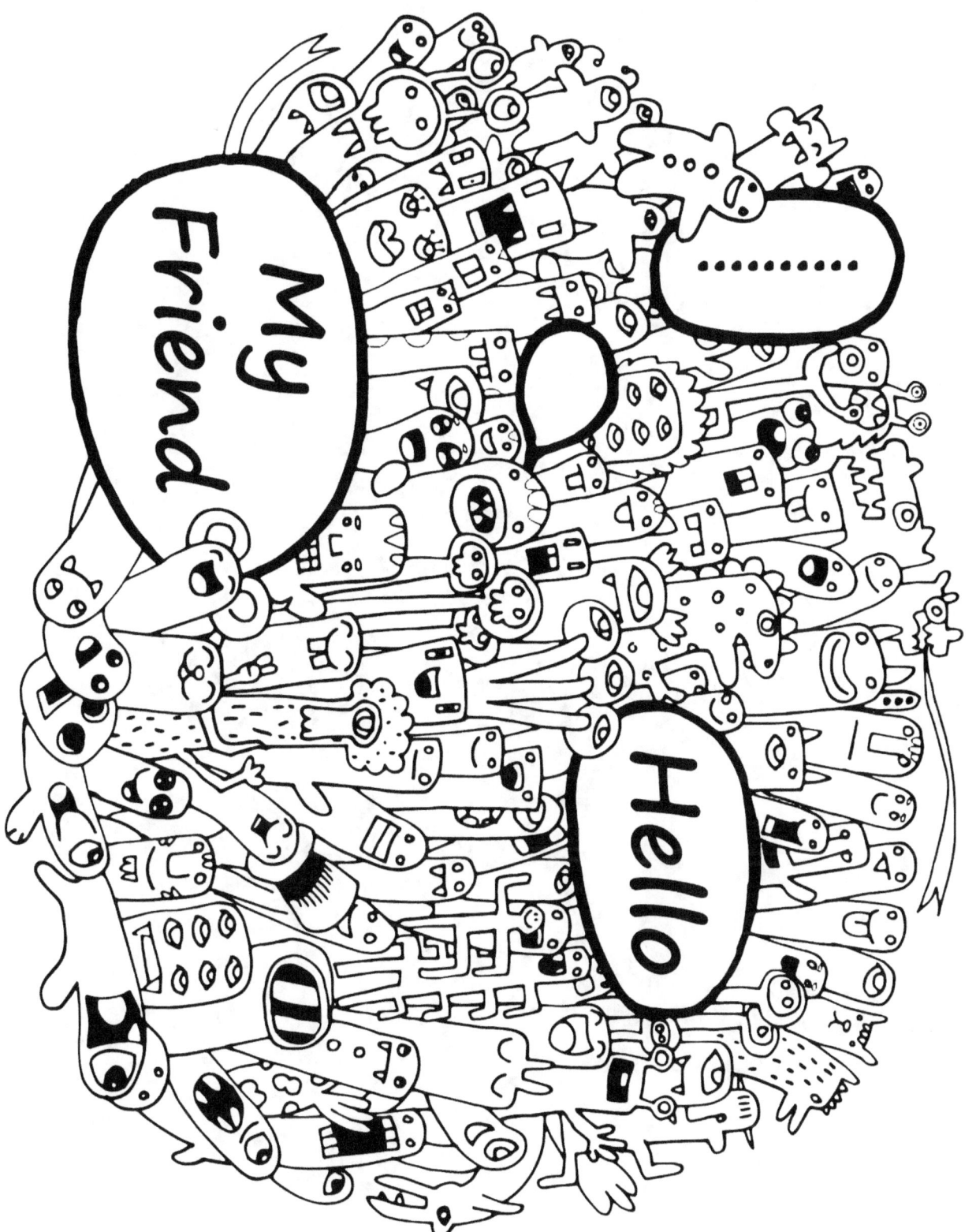

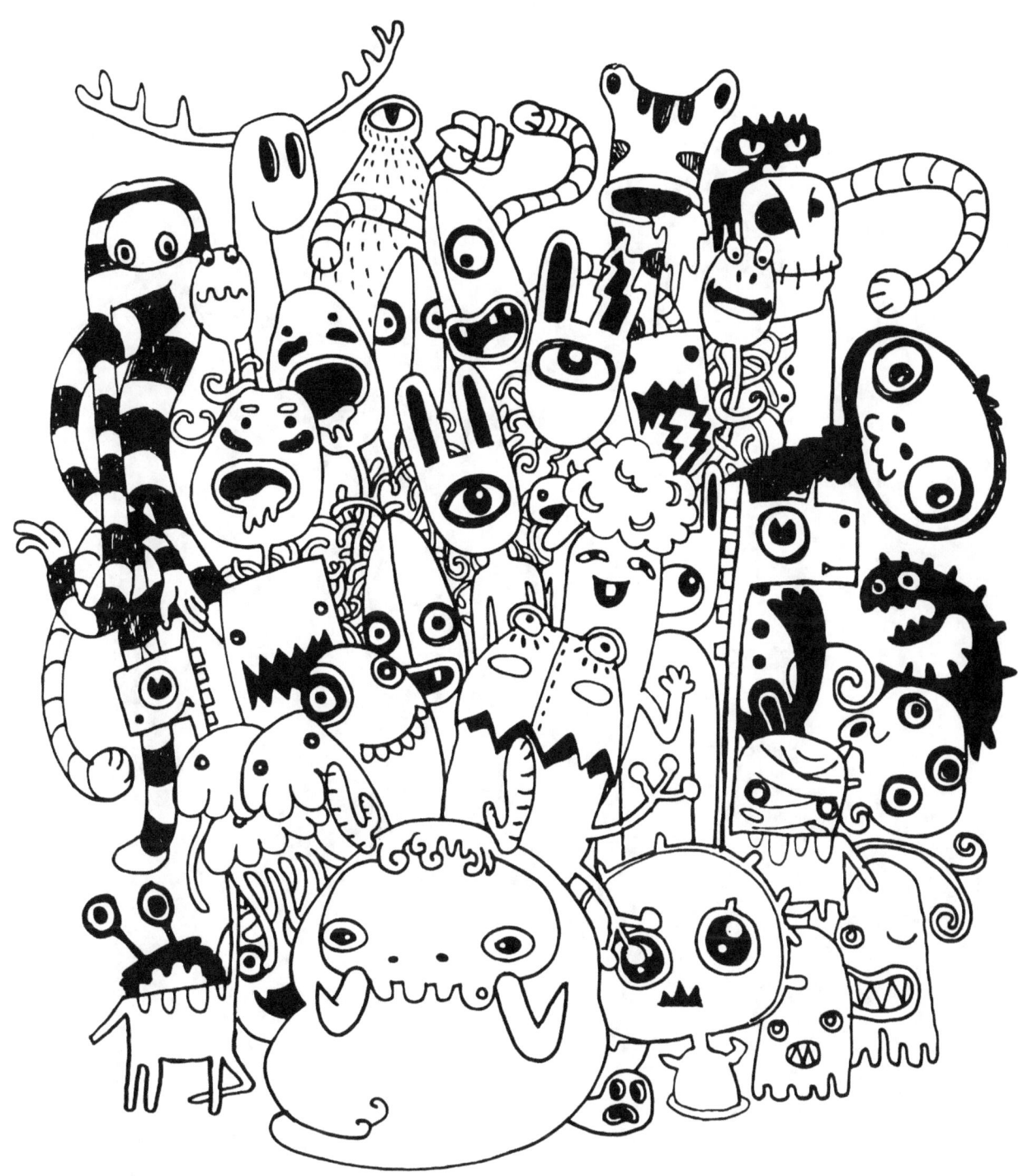

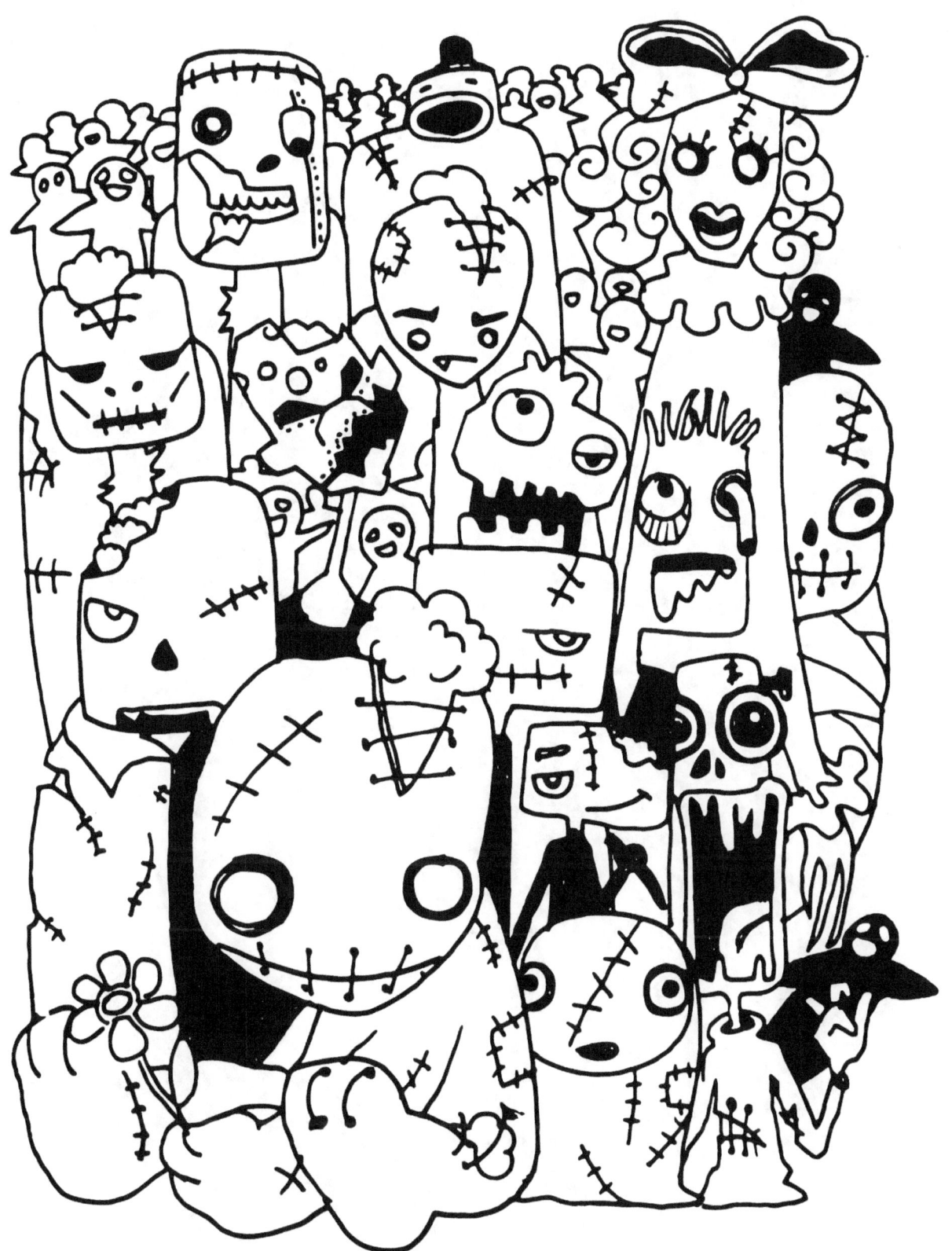

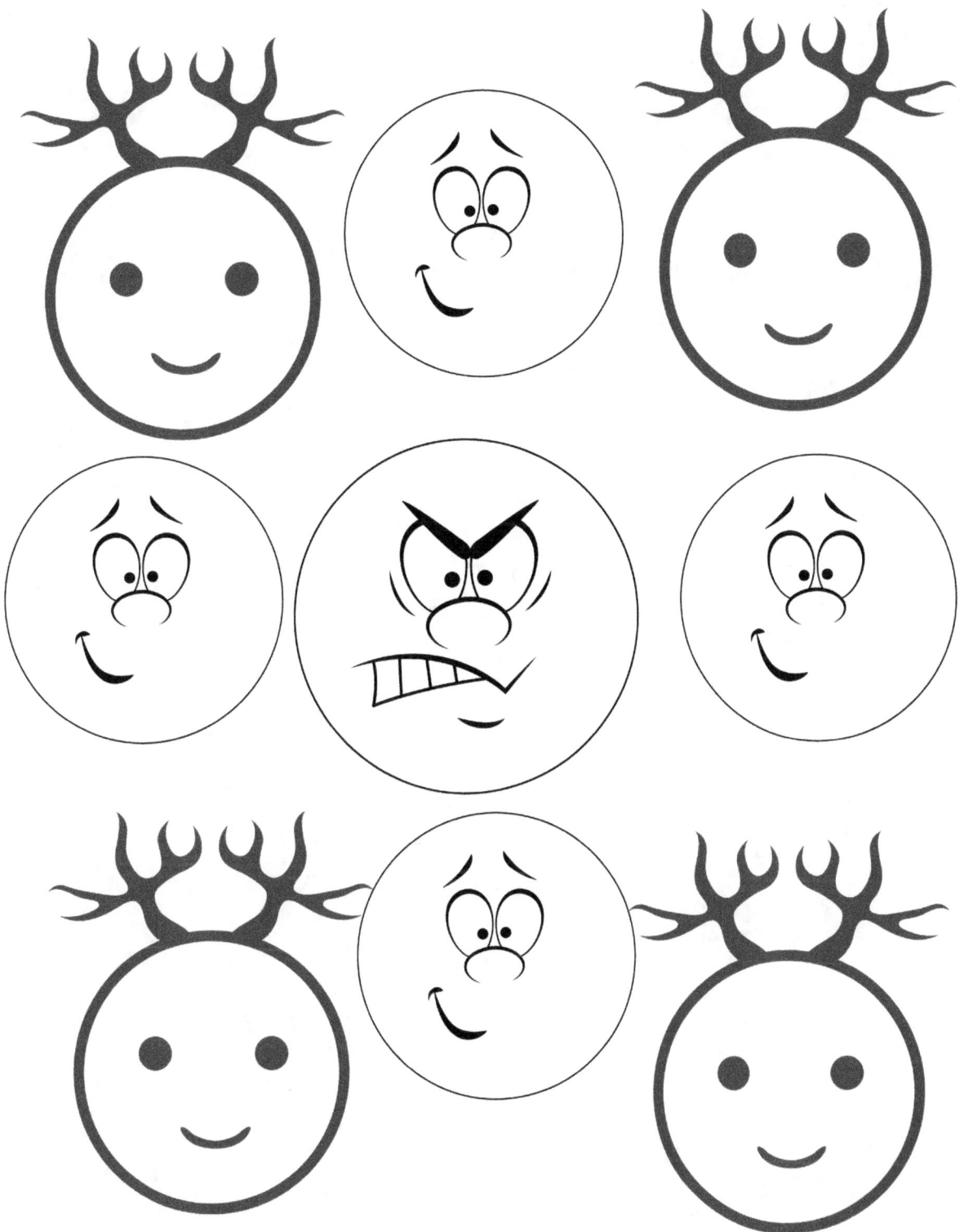

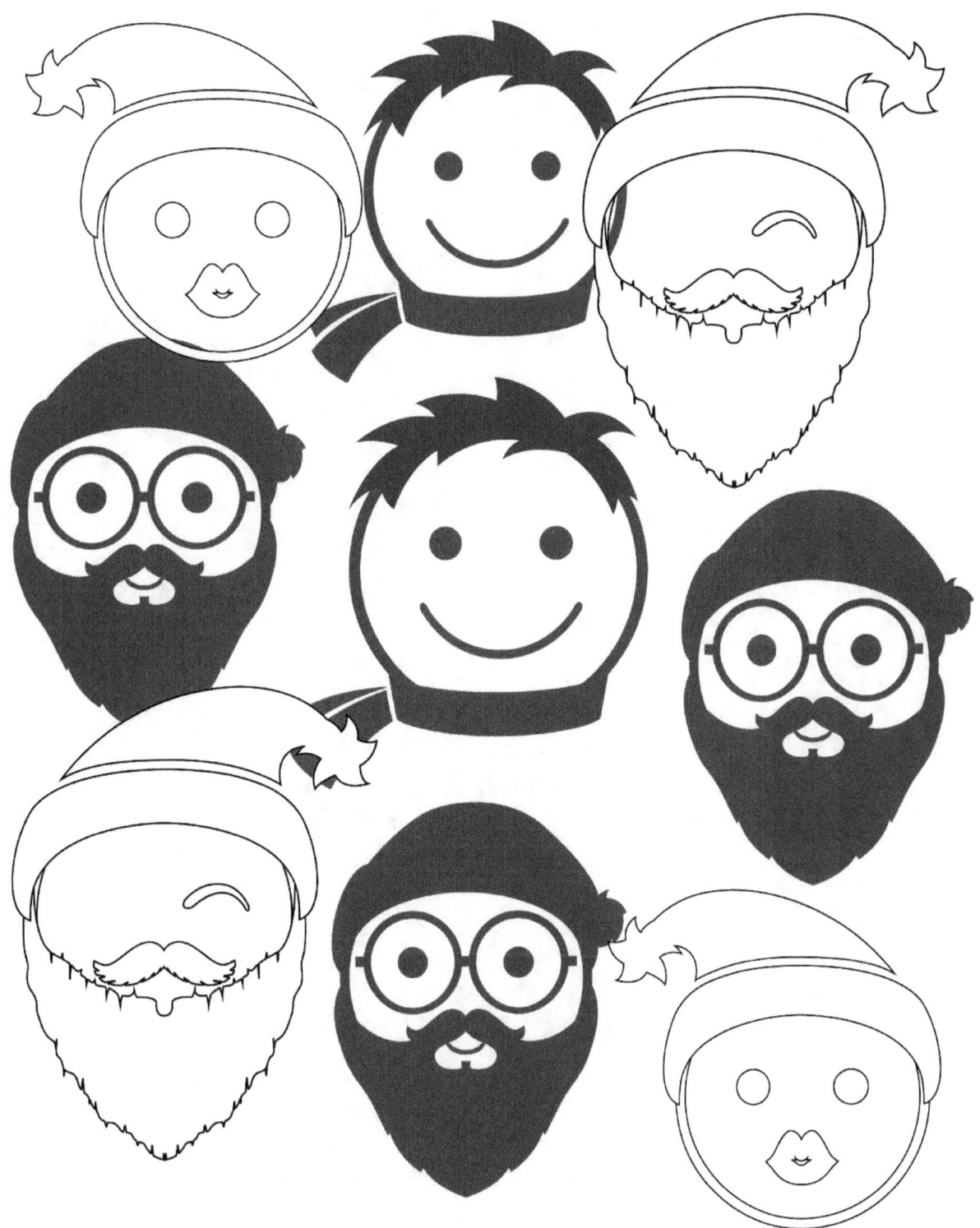

Thank You

Hope you've enjoyed your reading experience.
We here at Adriana P. Jenova will always strive to deliver to you the highest quality guides.
So I'd like to thank you for supporting us and reading until the very end.
Before you go, would you mind leaving us a review on Amazon?
It will mean a lot to us and support us creating high quality guides for you in the future.
Thanks once again and here's where you can leave a review.
Get Free Illustration Coloring Page Below
www.allcoloringbook.com

Warmly yours,
Adriana P. Jenova Team

www.ingramcontent.com/pod-product-compliance
Lightning Source LLC
Chambersburg PA
CBHW060601210526
45170CB00020BA/2967